Nikon D90

Focal Digital Camera Guides

Nikon D90

Corey Hilz

Focal Press is an imprint of Elsevier 30 Corporate Drive, Suite 400, Burlington, MA 01803, USA Linacre House, Jordan Hill, Oxford OX2 8DP, UK

© 2009 Corey Hilz. Published by Elsevier, Inc. All rights reserved.

No part of this publication may be reproduced, stored in a retrieval system, or transmitted in any form or by any means, electronic, mechanical, photocopying, recording, or otherwise, without the prior written permission of the publisher.

Permissions may be sought directly from Elsevier's Science & Technology Rights Department in Oxford, UK: phone: (+44) 1865 843830, fax: (+44) 1865 853333, E-mail: permissions@elsevier.com. You may also complete your request online via the Elsevier homepage (http://elsevier.com), by selecting "Support & Contact" then "Copyright and Permission" and then "Obtaining Permissions."

Recognizing the importance of preserving what has been written, Elsevier prints its books on acid-free paper whenever possible.

Library of Congress Cataloging-in-Publication Data

Hilz, Corev.

Nikon D90 / Corey Hilz.

p.cm. - (Focal digital camera guides)

Includes bibliographical references and index.

ISBN 978-0-240-81189-5 (pbk.: alk. paper) 1. Nikon digital cameras-Handbooks, manuals, etc. 2. Single-lens reflex cameras-Handbooks, etc. 3. Photography-Digital techniques-Handbooks, manuals, etc. L. Title.

TR263.N5H5253 2009

771.3'1-dc22

2008052626

British Library Cataloguing-in-Publication Data

A catalogue record for this book is available from the British Library.

ISBN: 978-0-240-81189-5

For information on all Focal Press publications visit our website at www.books.elsevier.com

09 10 11 12 13 5 4 3 2 1

Printed in Canada

Working together to grow libraries in developing countries

www.elsevier.com | www.bookaid.org | www.sabre.org

ELSEVIER

BOOK AID

Sabre Foundation

Table of Contents

Introduction	VII
What's in the Box?	ix
Visual Tour	xi
Quick Start	xix
How to Get Good Photos Out of the Camera	
in 5 Minutes	xxiii
Part 1: The Camera	1
Making Pictures	3
Viewing/Reviewing Images	63
Menus	81
Batteries, Memory Cards and Maintenance	147
Part 2: The Software	151
Building an Image Library	153
Nikon Transfer	155
Nikon ViewNX	163
Capture NX	178
Part 3: The Light	187
Using Natural Light	189
Direction of Light	192
Inclement Weather	196
Lighting Comparison	197
Part 4: The Lenses	201
Zoom Lenses	206
Fixed Focal Length Lenses	206

vi Table of Contents

Maximum Aperture	207
Focusing	207
Wide-angle Lenses	209
Standard Lenses	210
Telephoto Lenses	211
Super Telephoto Lenses	212
Zoom Lens Choices	213
Macro Lenses	218
Part 5: Composition & The Subjects	221
Composition Techniques	223
Portraits & People	227
Travel	229
Pets and Animals	231
Action	232
Products	234
Part 6: Accessories	235
Flash Units	237
Remote Control	237
Filters	238
Viewfinder Accessories	240
HDMI Cable	241
Power Sources	241
Links	243
Index	245

Introduction

The Nikon D90 is a compact single-lens reflex (SLR) camera that's easy to carry around and meets a variety of photographic needs. It offers a full set of features for different shooting situations. The D90 can capture your fast action shots and perform well in low light situations that require higher ISOs. Combine it with a wide angle and telephoto lens and you'll be covered in most situations. We'll explore all the camera's functions that allow you to capture such a range of subjects in this book.

Digital camera technology is always improving and the D90 takes advantage of the latest advances. It broke ground as the first digital SLR to have high definition video. You'll definitely want to check it out. It's closely tied to live view, another new feature to this level of Nikon camera. There's even a new display mode that shows the shooting information on the back LCD. A great alternative to trying to identify those tiny symbols on the small LCD on top. The D90 also includes a feature called D-Lighting which helps you capture photos with more detail in the brightest and darkest areas of your photos. But it doesn't stop with taking the picture. Want to adjust your photos before you get them on your computer? With the D90 it's easy to do. Changing colors, cropping, resizing, and converting to black and white are all adjustments you can do right from the camera. And let's not forget about the self-cleaning sensor. Can you tell we've got a lot to cover in the pages ahead? Whether you plan to photograph people, architecture, nature, action or landscapes, at home or abroad you'll find features in the D90 that'll help you capture your best shot. Let's get started!

What's in the Box?

To get started, let's take a quick look at what came in the box with your D90.

 Nikon camera strap. This is a sturdy nylon strap, but if you'd prefer a different style or one with more padding take a look at manufacturers that specialize in camera straps, such as OP/TECH USA.

 USB cable. Used for connecting the camera to your computer or a printer.

• Audio/Video cable. Used to connect the camera to a television.

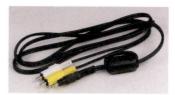

- EN-EL3e rechargeable battery
- Battery charger

 Viewfinder cover. Used when doing long exposures to avoid light coming in the viewfinder.

- LCD monitor cover. Protects LCD from getting dirty or scratched. Comes already attached to the camera.
- Manual, Quick Guide, Software Installation Guide and Warranty Card
- Software CD for installing Nikon Transfer and Nikon ViewNX

Visual Tour

In this section we'll look at all the buttons, dials, and other features on the D90. This overview will help you become familiar with the layout of the camera. I've also included a brief description of each feature. As you read the rest of the guide use these pages as a reference to find a button or as a reminder as to what it does.

FRONT OF THE CAMERA:

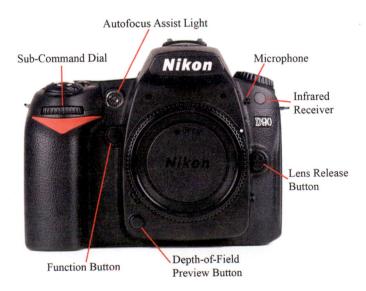

Sub-Command Dial: This dial is used to change various settings found on the LCD panel on top of the camera.

Autofocus Assist Light: Even though the name refers to autofocusing, this light is actually used for a few functions: (1) lighting up subjects to help the lens focus, (2) indicating the self-timer is active, and (3) lighting up before the flash fires to reduce red-eye.

Microphone: The microphone is used to record sound while recording a

Infrared Receiver: This dot is what receives the signal from a wireless remote.

Lens Release Button: Use this button when you want to remove or change the lens. Press the button and hold the camera in one hand. With your free hand turn the lens to the left to detach it.

Depth-of-Field Preview Button: Look through the viewfinder while you press and hold this button and you'll see a preview as to how much of your subject/scene will be in focus.

Function Button: Used as a shortcut button to access a selected feature.

INSIDE THE CAMERA

If you take off the body cap on the front of the camera, you'll see a mirror inside. The mirror bounces the light up into the viewfinder, which is what lets you see what the lens sees. The sensor that records your photograph is located behind the mirror.

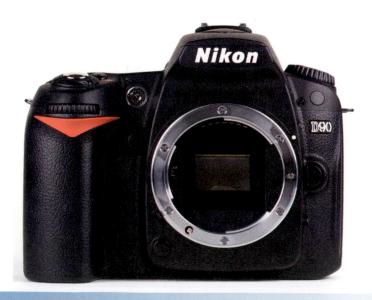

LEFT SIDE OF THE CAMERA

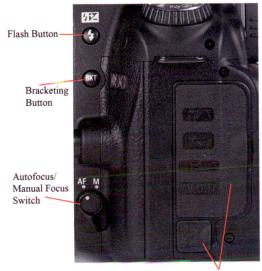

Connector Covers

- Flash Button: Press this button to release the pop-up flash (in P, S, A or M exposure modes). You can also use it to change the flash mode as well as increase or decrease the power of the flash.
- Bracketing Button: Press this button to access the bracketing settings.
- Autofocus/Manual Focus Switch: Use this switch to choose between autofocus and manual focus.

Connector Covers: Open these covers to access the following connection ports.

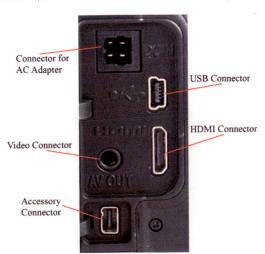

- AC Adapter: Plug in an AC Adapter to power the camera for extended periods of time.
- Video: Connect your camera to a television using the Audio/Video cable that came with the D90.
- · Accessory: You can connect a remote cable release or GPS unit using this connector.
- USB: Use the USB cable that came with the camera to connect it to a computer or printer.
- HDMI: Use an HDMI cable to connect the D90 to a high-definition device (not provided).

RIGHT SIDE OF THE CAMERA

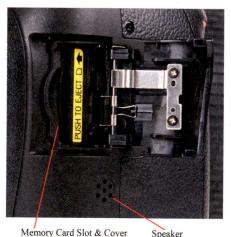

- Speaker
- Memory Card Slot: The D90 uses SD memory cards.
- Speaker: Used for audio playback of video recorded with the D90.

TOP OF THE CAMERA

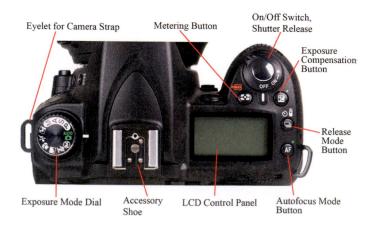

You'll be using the buttons and dials on the top of the camera frequently.

On the left and right sides are two eyelets for attaching a camera strap.

The LCD Control Panel shows you the settings for various functions, many of which can be changed using the buttons and dials on the camera body.

- The On/Off switch surrounds the shutter-release button.
- The Metering button lets you select the metering mode.
- The "+/-" button is the Exposure Compensation button. This is used to increase or decrease the exposure (making an image brighter or darker).
- The Release Mode button is for choosing if you want to take photos one at a time, continuously, use a remote or use the self-timer.
- The Autofocus Mode button lets you choose between modes for still or moving subjects.
- In the middle is the Accessory Shoe where an external flash unit can be attached. The D90 comes with a protective cover over the shoe. To remove it, slide the cover toward the back of the camera.
- The dial on the top of the camera is used to select the exposure mode.

CONTROL PANEL INFORMATION

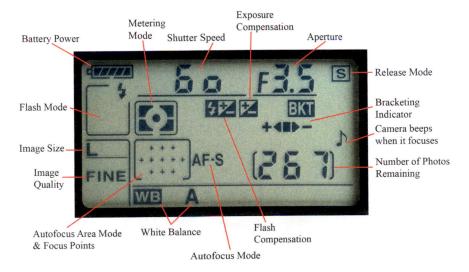

BACK OF THE CAMERA

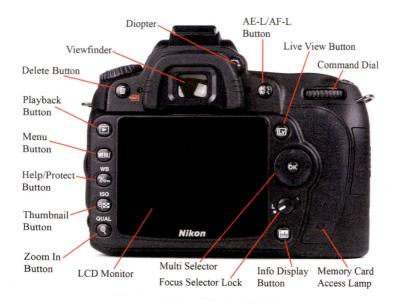

Viewfinder: Allows you to see your subject exactly as the lens is seeing it.

LCD Monitor: Used to view your photos as well as access the menus and adjust your shooting settings.

Command Dial: Used for changing settings for the exposure modes and other options.

Memory Card Access Lamp: Lights up whenever the camera is reading from or writing to the memory card.

- **Diopter:** The diopter adjustment is an important feature used to make sure that when the lens brings your subject into focus, the subject also appears sharp to your eyes.
- Delete button for deleting images during playback.
- Playback button for reviewing images on your memory card.
- Menu button for accessing the menu options.
- While in the menus the Help/Protect button accesses Help information about various camera settings and functions. During playback it's used to protect photos from being deleted. When photographing it's used to change the white balance.
- Thumbnail button for viewing images as thumbnails and making images smaller during playback. When photographing it is used to change the ISO.
- [Zoom button for making images larger during playback. When photographing it is used to change image quality and size settings.
- Info Display button for accessing the setting screen for shooting functions.
- Focus Selector Lock prevents the focusing point from being changed while photographing.

Live View button for activating live view mode.

AE-L/AF-L button is used to lock the autofocus and/or auto exposure readings.

SHOOTING INFORMATION DISPLAY

Press the (info) button to display this info.

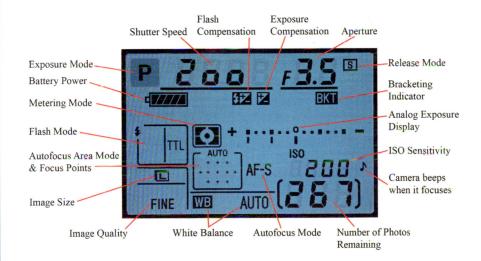

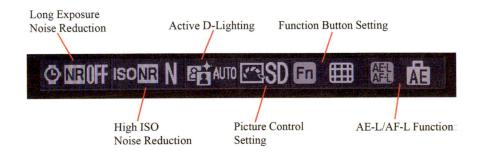

CONVENIENT FEATURES

In-camera help

When you're changing a setting in a menu or accessing the settings at the bottom of the shooting information display there is often a question mark in the bottom left of the LCD screen. If you see the question mark it means you can press and hold the button to display a description of the setting/option you currently have selected. This can be particularly helpful if you need a quick reminder of what a setting does.

Here is the Long Exposure Noise Reduction setting and what the in-camera help tells you about it.

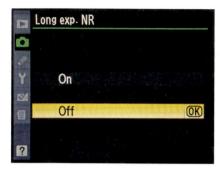

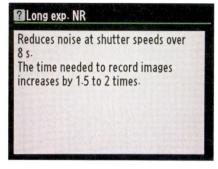

Shooting information display

You can bring up the shooting information display by pressing the into button while in any mode. The monitor displays the same info as the control panel on top of the camera, plus more. You can use this display just as you would the control panel. As you change aperture, shutter speed, etc. the information displayed will change. This display is useful for a few reasons. Everything is larger compared to the control panel, therefore easier to see. Also, if you can't see the control panel due to the position of the camera, you can use this display instead. Finally, if you press the button a second time you'll be able to change the settings across the bottom of the monitor. There's a lot packed into this display!

Quick Start

No doubt you're eager to start taking pictures with your new D90. Don't want to read the whole book just to start taking pictures? Then this is the section for you! You'll learn the basics of your camera and how to start taking good pictures. It covers everything from charging the battery and inserting the memory card to composing and reviewing images.

If you're already familiar with SLR cameras and would like to starting learning in detail about the various options and controls of the D90, you may prefer to skip this introductory section and start with Part I.

WHAT DO YOU NEED TO GET STARTED?

- D90
- Charged battery
- Lens
- Memory card

CHARGING THE BATTERY

To use the charger attach the charger cord to the charger and plug in the cord. The battery fits into the recessed area on top of the charger. Orient the battery so that the end with the triangle (next to the word "Nikon") points toward the "Nikon QUICK CHARGER" label on the charger. Set the battery in the recessed area near the top then give it a good push to slide it into the connectors. The battery will click into place and begin charging. An orange light on the top of the charger will start blinking continuously. When the charge is complete the light will stay solld orange. It'll take a bit over two hours to fully charge the battery.

INSERTING THE BATTERY

- Make sure the camera is off before inserting the battery.
- The door to the battery compartment is on the bottom of the camera. Push the lever on the compartment door toward the center of the camera. If you do this while holding the camera upright the door will drop down, opening the compartment.
- Slide the battery into the compartment. (Orienting the battery: Have the side that says "Nikon" facing up and insert the end with the triangle first) Press the battery door closed.

SETTING THE DIOPTER

The diopter is located to the right of the viewfinder. It's important to set the diopter so you're able to see when your subject is sharp. If it's set incorrectly, autofocus will still focus the lens on your subject, but the subject may appear blurry to you. You only have to set the diopter once.

Remove the body cap from the D90 (or remove the lens if you've already attached one). Look through the viewfinder and point the camera at something bright so you can easily see the boxes in the viewfinder. Rotate the diopter with your thumb while looking through the viewfinder until the boxes are sharp. Give it a good push as the diopter doesn't always turn easily.

Note: If you wear glasses when photographing, have them on when you set your diopter. The opposite is also true. If you don't wear glasses when photographing, don't wear glasses when you set your diopter. The diopter is correcting the viewfinder for your vision, so you want to see the viewfinder under the same circumstances as when you're taking a picture.

ATTACHING A LENS

Remove the cap on the back of your lens by turning the cap to the right.

On the back of the lens there is a small white circle along the outer edge. Look for a matching white circle on the camera body, along the edge of where the lens attaches. As you fit the back of the lens into the opening in the camera, line up the two circles. Once the circles are aligned the lens will fit flush with the camera. Rotate the lens to the right until it locks into place.

INSERTING A MEMORY CARD

Make sure the camera is off before inserting the memory card.

The D90 uses a Secure Digital (SD) memory card. The card slot is located on the right side of the camera (when looking at the camera from the back). Open the cover to the memory card slot

by pressing and sliding the cover toward the back of the camera.

It's important to orient the card correctly when inserting it into the camera. One corner of the memory card looks as though it has been cut off. The end with this clipped corner goes into the camera first. The side labeled with the name of the card should be facing the back of the camera.

Always turn the camera off before removing the memory card. To remove the card, simply press down on the card and it will pop out partway when you lift up your finger.

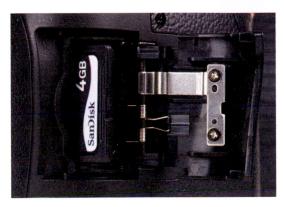

Press the card into the slot until it locks in place.

TURNING THE CAMERA ON FOR THE FIRST TIME

 Around the silver shutter release button is the On/Off switch. Push the switch to the right to turn the camera on.

 As soon as the D90 is turned on the LCD on the back lights up and the camera asks you to pick a language. Highlight the language you would like by using the up and down buttons on the multi selector to the right of the LCD. Once the language you want is highlighted, press the OK button in the center of the multi selector.

- Next select your time zone. Use the left and right buttons on the multi selector to move the yellow stripe to the correct time zone. Press the OK button.
- Choose to have Daylight Saving Time on or off. Press the OK button.
- Set the date and time. Use the up and down multi selector buttons to change the numbers. Use the left and right buttons to move from one number box to the next. Press the OK button when done.
- The D90 will then display "Done" and the LCD will go dark. Your camera is now ready to take pictures!

If there is a lot of information displayed in the control panel the camera is on. When the camera is off the only info shown is the number of pictures remaining. Also, near the shutter release button is a vertical white line (between the metering mode and "+/-" buttons). Look at which word is above the line to see if the camera is on or off.

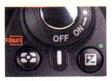

FORMATTING YOUR MEMORY CARD

Before you take pictures using a new memory card you should format the card in the camera. Whenever you want to erase all the photos on the memory card you must format it again.

Press the button, then use the multi selector to move through the menus. Press the multi selector left to make sure you're in the main menu categories. Then press down to go to the Setup Menu. Press right to move over to the Format Memory Card option. Press the button to choose it. A warning message will appear to make sure you really want to delete all your photos.

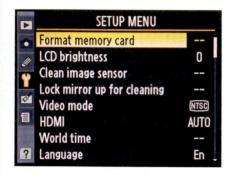

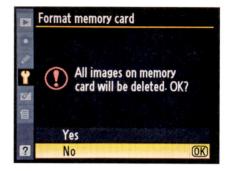

At this point you don't have any photos on the card so you don't have to worry about deleting anything. Select Yes and press the object Yes and press the

How to Get Good Photos Out of the Camera in 5 Minutes

This section goes through the steps to get your D90 set up as quickly as possible to start taking good pictures. The other settings and options available will be described in detail later in the book. In subsequent sections I'll also discuss why some settings are better than others, as well as what settings to use in certain situations.

BASIC SETUP

If you've done everything listed in the previous Quick Start section (charged battery, adjusted diopter, attached lens, inserted memory card), then there are just a few more steps and you'll be ready to start taking pictures.

- 1. Turn the camera on.
- 2. Turn the dial on the top of the camera so that "Auto" (in green) is next to the white line.

- 3. Hold down the sutton on the back of the camera. Then turn the command dial (by your thumb). This will change the Image Quality. Choose the FINE setting.
- 4. Hold down the button again. Then turn the sub-command dial (by your index finger). This will change the Image Size. Choose the L setting.

5. Hold down the button on the top of the camera. Then turn the command dial. This will change the Release Mode. Choose the S sotting.

6. Hold down the button on the top of the camera. Then turn the command dial. This will change the Autofocus Mode. Choose the AF-A setting.

7. Set the autofocus/manual focus switch to AF.

HOW TO HOLD THE CAMERA

Your right hand wraps around the right side of the camera. Place your thumb near the dial at the top right on the back of the camera. The index finger on your right hand is used to push the shutter release button, turn the camera on and off, and use nearby buttons.

To best support the camera place your left hand, palm up, against the bottom of the camera. Let your left hand support some of the weight of the camera and lens. Have your fingers reaching out in front of the camera, under the lens. Use your fingers to make adjustments to the lens such as zooming and manual focusing.

COMPOSING AND FOCUSING

- Look through the viewfinder to compose your picture. Use your left or right eye, whichever is more comfortable.
- If you're using a zoom lens, turn the zoom ring to make your subject bigger or smaller in the viewfinder.

- Place your subject in the middle of the viewfinder.
- · Press the shutter release button down halfway. This activates autofocus and the subject in the middle should now appear sharp.
- Press the shutter release button down the rest of the way to take the picture.

REVIEWING

Your photo will appear on the back of the camera right after you take the picture. If the monitor on the back goes dark, just press the 📵 button to bring the pictures back. You can look at other photos you've taken by pressing left or right on the multi selector.

DELETING

If want to delete a photo simply press the 📵 button and this message will appear:

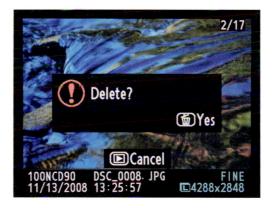

If you pressed the delete button by mistake, press to cancel.

Press a second time to confirm you want to delete the photo.

That's it! You now have the basic settings for a good exposure, you know how to focus on your subject, and you're able to review and delete your photos.

The Camera

Section A: Making Pictures Section B: Viewing/Reviewing Images Section C: Menus

Section D: Batteries, Memory Cards,

and Maintenance

Section A: Making Pictures

EXPOSURE

Every time you take a picture there are a couple things you want to happen so you get a good picture. You want a good exposure and your subject to be in focus. Whether you choose all the settings on the camera or your camera does it for you, it's important to understand what's controlling how your picture looks.

The exposure is determined by how much light reaches the camera's sensor. A "good exposure" means that your photo is not too bright or too dark. There are two settings that control your exposure: aperture and shutter speed. They also have a big affect on the appearance of the subject or scene you're photographing. The details about these settings can get a little technical, but bear with me. If you understand the general idea of aperture and shutter speed, it will make it easier for you to capture the pictures you want. As we go through this information you'll learn how to:

4 The Camera

• Have just one element in focus, such as a flower

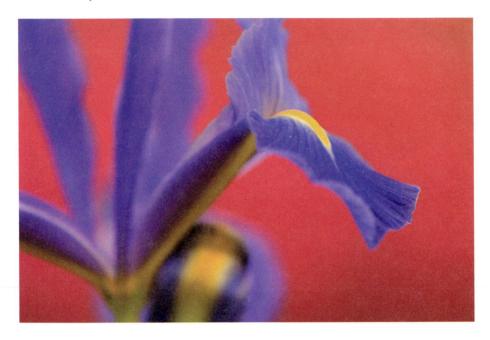

• Keep everything in focus, as with a landscape

• Freeze a moving subject, like this chipmunk

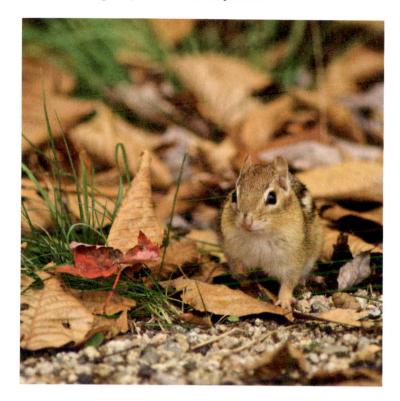

• Blur a moving element, such as a river

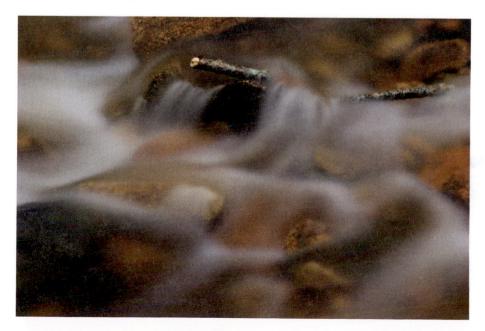

APERTURE

Inside the lens there's an opening called the aperture. This opening controls how fast the light comes into the lens. You can have a very large hole or a tiny one. A big hole is going to let a lot of light into the lens very quickly. With a small hole the light comes in much slower. Every lens allows you to change the size of the opening by changing the aperture setting.

Take a look at these photos to see the actual size of the openings and the number that goes with each one.

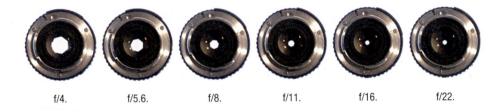

Notice that each number has an "f" in front of it. When saying an aperture number you also include the "f". For instance f/11 is said "f-eleven." Because of this we also call apertures "f-stops." You can use the terms aperture and f-stop interchangeably. You could ask someone "What aperture are you using?" or "What f-stop are you using?" and it would mean the same thing.

Now that you know what an aperture is, what does it have to do with your picture? The aperture controls how much of your photo is in focus. Think about photos you've seen where there is just one thing in focus and the background is a blur of color. Now think about a landscape photo where every little detail was in focus. These two extremes of having one element in focus or having everything in focus is the result of changing the aperture.

The wide apertures (large opening) are f/4 and f/5.6. Using these apertures will have just a little bit of your subject in focus. This photo was taken at f/4. Notice how just one flower is in focus and all the flowers in front of and behind it are out of focus.

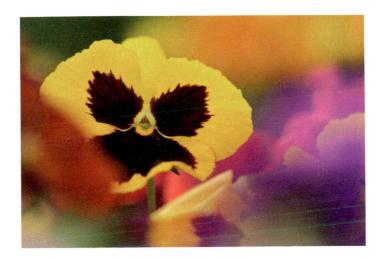

The next apertures, f/8 and f/11, are the mid-size openings. These apertures are good for having a moderate amount of your subject or scene in focus. They are good for bringing a group of things in focus, but still keeping the background out of focus. The photo below was taken at f/11. Notice how the mailbox and the window frame are in focus, but the leaves in the background are a little blurry.

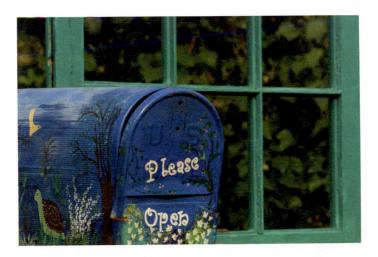

The final two apertures, f/16 and f/22, are the smallest ones. Use them when you want to bring as much of your scene/subject into focus as possible. I used f/22 when I took this photo so that everything would be sharp from the grass in the foreground to the tree line in the background.

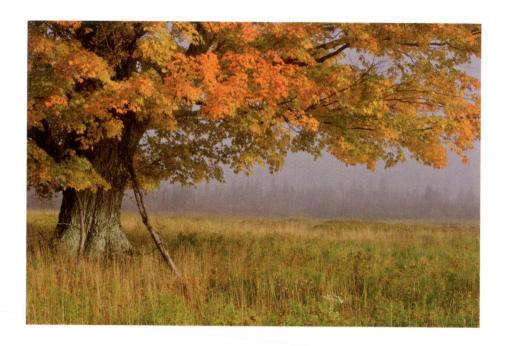

Looking back on what we just learned, does it seem odd that the small number (f/4) refers to a big opening and the large number (f/22) is a little opening? Let me explain since this can be

a bit confusing. The f-stop numbers are actually fractions. So "4" is really "1/4" and "22" is "1/22." Now it makes more sense since 1/4 is larger than 1/22. Hopefully this helps straighten things out in your head. It does take some practice to get comfortable with which aperture does what.

DEPTH OF FIELD

How much is in focus is also called "depth of field." Using a large aperture (f/4) decreases the depth of field (a little in focus). A small aperture (f/22) increases depth of field (a lot in focus).

Here's the same composition photographed at four different apertures.

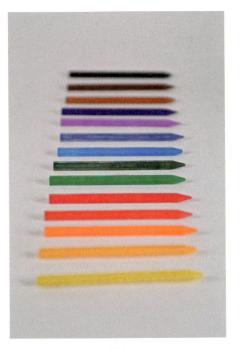

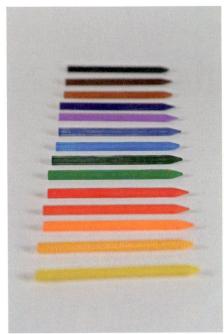

f/2.8.

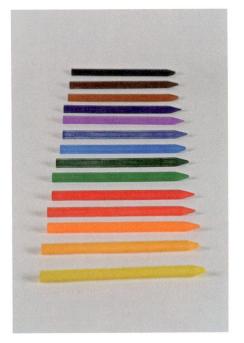

f/5.6.

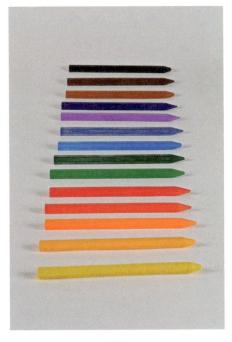

Using f/2.8 just has one of the crayons in focus. When a smaller aperture is used more of the crayons are brought into focus. Notice how the area in focus extends in front of and behind the original point of focus (green crayon). When smaller apertures bring more into focus, they do so in both directions (forward and back) from where you focus the lens. Depth of field does not "move" in just one direction. Part of choosing an aperture is deciding how you want your photograph to look. There's no right or wrong aperture to use, it depends on what you want to be in focus.

SHUTTER SPEED

Inside your camera the sensor is covered by the shutter blades. The shutter blades open when you press the shutter release button to take a picture. While the shutter is open light is reaching the sensor and an image is recorded. The amount of time the shutter blades are open is called the shutter speed.

Light is coming into the camera whenever the lens cap is off, but it can't reach the sensor until you press the shutter release button and the shutter blades open.

The D90 has a range of shutter speeds from very fast (1/4000 of second) to very slow (30 seconds) as shown below.

1/4000

1/2000

1/1000

1/500

1/250

1/125

1/60

1/30

1/15

1/8 1/4

1/2

1

2

4

8

15 30

When the shutter speed is slow it is harder to hold the camera still for the entire exposure. Your subject may not be moving, but if your hands are moving slightly (called hand shake) then your picture will be blurry. If you find yourself having to use shutter speeds where you can't hold the camera still, it may be necessary to use a tripod. A tripod will hold the camera absolutely still no matter how slow the shutter speed.

BULB SETTING (ONLY AVAILABLE IN MANUAL EXPOSURE MODE)

After the slowest shutter speed of 30 seconds is the Bulb setting. When Bulb is selected the shutter will stay open for as long as you keep the shutter release button pressed down. Think of the Bulb setting as manual shutter speed. Since you can set the shutter speed for any length up to 30 seconds, you'd use Bulb if you wanted to use a shutter speed longer than 30 seconds. You'll definitely want to be on

a tripod if vou're using Bulb to ensure the camera stays still.

You can use different shutter speeds to affect how moving objects appear in your photos. To freeze the motion of a moving object you'd choose a fast shutter speed. Using a slow shutter speed would allow you to manipulate the appearance of a moving object by blurring it.

When you see the shutter speed on the control panel (to the left of the f-stop) and it has quotation marks to its right then the number is in seconds. No quotation marks means the number is a fraction of a second.

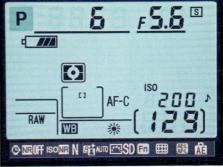

Shutter speed is 1/6 of a second.

Being able to choose different shutter speeds gives you the opportunity to experiment with how you want a moving subject to look. The waterfall photos show how water can be captured in a semi-frozen state or made silky smooth.

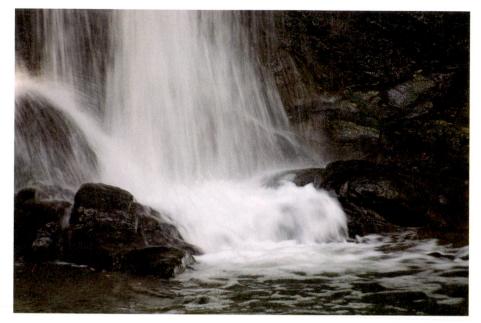

1/15 of a second.

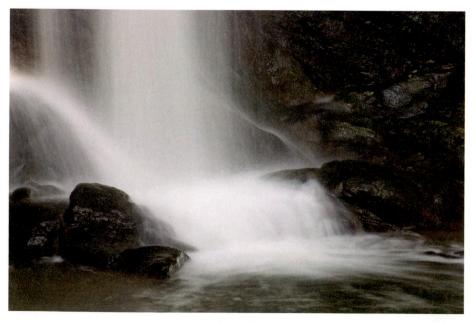

1 second.

Take a look at this series of photos and what shutter speeds were used to capture them.

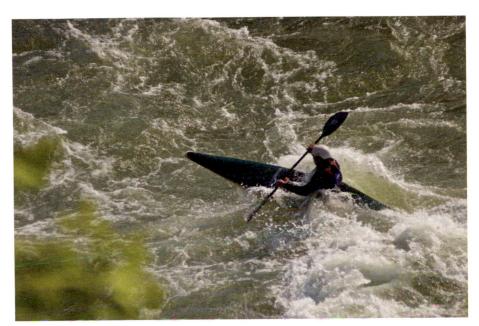

1/100 of a second. Using a very fast shutter speed allowed me to freeze the action of the kayaker and the water around him.

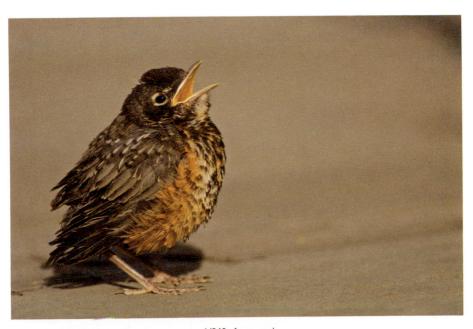

1/640 of a second.

When photographing this young robin a fast shutter speed was necessary to capture the brief instant it opened its beak.

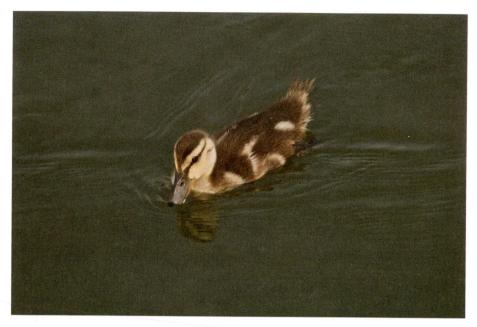

1/200 of a second.

As this duck was swimming toward me I needed a fast enough shutter speed to stop its motion. The duck was not moving extremely quickly so 1/200 of a second was fast enough to keep it from blurring.

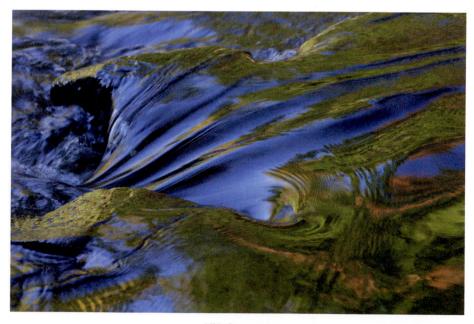

1/25 of a second.

In this photograph of reflections in a river, a slower shutter speed renders a combination of areas that are smooth and others that are distinct.

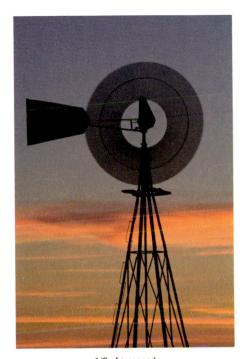

1/3 of a second. A slow shutter speed of almost a half second allowed me to capture this graphic blur of a spinning windmill at sunrise.

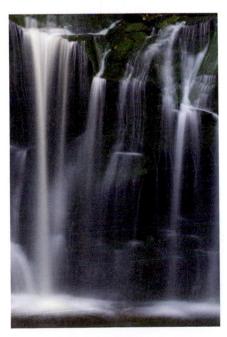

4 seconds.

To make water look silky smooth, often a shutter speed of 1/2 second or slower is necessary. I took this photo in a forest where the lighting was very dim, so an even slower shutter speed was required.

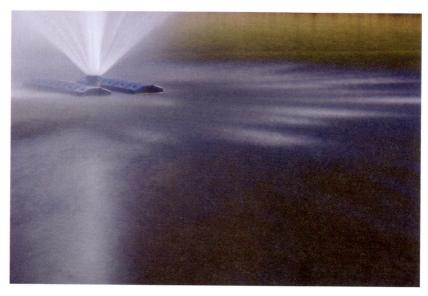

13 seconds.

It was a bright, sunny day when I photographed this fountain. To make the water in the fountain very smooth and blur the slow moving water in the lake, I needed a very slow shutter speed.

EXPOSURE MODES

Now that we have an idea how aperture (or f-stop) and shutter speed affect our pictures, let's look at the exposure modes on the D90. Use the dial on top of the camera to pick one of the exposure modes. As you can see there are a lot to choose from! Let's take a look at each mode, see what options it offers, and when you should use them.

To set the exposure mode turn the dial so that the letter or symbol for the mode you want is lined up with the white line.

AUTO mode is selected.

First a quick overview of the exposure modes. About half the dial has letters representing shooting modes. These are your standard modes. The other modes are represented by symbols. These symbols are specialized exposure modes for taking specific types of pictures:

P — Program

S — Shutter Priority

A — Aperture Priority

M — Manual

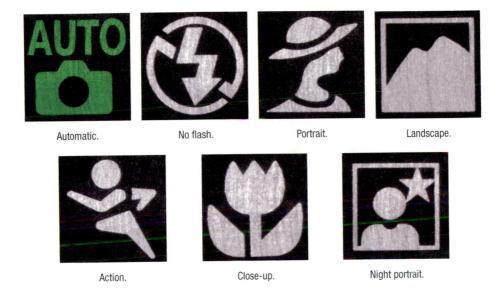

PROGRAM

In the Program mode the camera does a lot of the work. It chooses the aperture and shutter speed for you. However, you are still able to control the rest of the camera settings such as white balance, ISO, flash, exposure compensation, and metering. This is a great mode when you want to take a quick snapshot, but still want some choice in what settings the camera uses.

Next we'll look at Shutter Priority and Aperture Priority. Recall that the exposure is controlled by the shutter speed and aperture. With these next two exposure modes you can choose to control the shutter speed or the aperture. They're useful modes because they allow you to have a little more control over the picture-taking process, but the camera still does some of the work for you.

SHUTTER PRIORITY

When using Shutter Priority you pick the shutter speed and the camera picks the aperture. This is convenient because you control the shutter speed but the camera still sets the aperture for you. You also have full control over all the camera's other settings.

Shutter Priority is best used when it's important for you to use a specific shutter speed; for instance, you're photographing a soccer game and you need a fast shutter speed to freeze the action. Use Shutter Priority and you can set the shutter speed to 1/500 of a second. Then you'll know the shutter speed will be fast enough.

To use Shutter Priority turn the dial to "S". Then turn the command dial (back of the camera) to pick your shutter speed.

If you press the button to bring up the shooting information notice there's an "S" in the top left corner indicating you're in Shutter Priority mode.

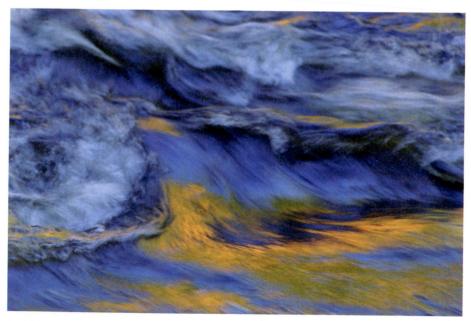

The shutter speed used when photographing moving water makes a big difference in the water's appearance. You can use Shutter Priority to pick the speed you want and know it's not going to change.

APERTURE PRIORITY

When using Aperture Priority you set the aperture and the camera chooses the shutter speed. This is convenient because you get to

select the aperture, but the camera still sets the shutter speed for you. You still have full control over all the other camera settings.

As you saw in the photos in the Aperture section, which aperture you choose can make a big difference in the background of your photo. Being able to choose the aperture gives you a lot of creative control over your image. If you're photographing a flower and you want a soft, blurred background, to able to choose f/4 or f/5.6 will let you achieve this. However, if you use an exposure mode where the camera picks the aperture for you, the camera has no idea what you want the background to look like. It's only concern is a proper exposure, so you may

not end up with the type of photo you want.

To use Aperture Priority turn the dial to "A". Then turn the sub-command dial (front of camera) to pick your aperture.

If you press the button to bring up the shooting information notice there's an "A" in the top left corner indicating you're in Aperture Priority mode.

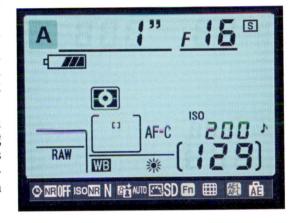

Aperture Priority mode is useful when you want to control how much is in focus.

MANUAL

In Manual mode you control *both* the shutter speed and aperture. This is a more advanced exposure mode because the camera is not choosing any settings for you. You might be thinking, how do I know what aperture and shutter speed combination to set? Even though you have to choose the aperture and shutter speed, the camera still provides some information to guide you in the right direction.

To use Manual mode turn the dial to "M". To pick the shutter speed turn the command dial. To set the aperture turn the sub-command dial.

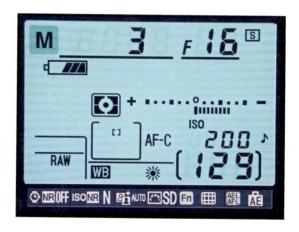

If you press the button to bring up the shooting information notice there's an "M" in the top left corner indicating you're in Manual exposure mode.

Next let's look at how to pick the right shutter speed and aperture combination. Bring up the shooting information display. Below the shutter speed and aperture numbers is a scale with "+" on the left, "0" in the middle and, "-" on the right. This is the Analog Exposure Display.

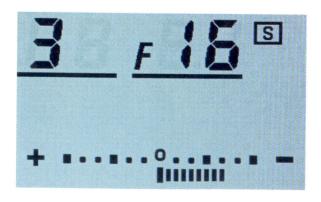

As you change the aperture and/or shutter speed the black lines below this scale will change. The number of lines will change and they'll either be on the left or right half of the scale.

The scale is telling you how your exposure settings (aperture and shutter speed) compare to what the camera thinks is a correct exposure.

A single black line below the zero in the middle means the exposure matches what the camera thinks is the correct exposure.

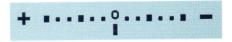

If the black lines are to the left of the zero, the exposure will be lighter than what the camera thinks is the correct exposure.

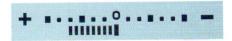

If the black lines are to the right of the zero, the exposure will be darker than what the camera thinks is the correct exposure.

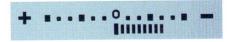

When setting your exposure manually, first choose the aperture or the shutter speed as your primary adjustment. The idea is to pick the one that gives you the best photograph.

Here are a couple scenarios. You'd want to set the shutter speed first if you're photographing sports so you choose a fast shutter speed. If you're shooting a landscape, you'd want to set the aperture first so you can pick a small aperture to get everything in focus.

Once you've chosen that first setting (aperture or shutter speed) leave it alone, and change the other setting. You want to adjust that other setting until there is only one line below the zero. This is a good place to start to check your exposure. Take a picture then look at the photo. Is it too light, too dark, or just right?

- If it's too dark (underexposed) turn the command (or sub-command) dial to the left and you'll add lines toward the "+" side. This will make your next picture lighter.
- If the photo is too light (overexposed) turn the command (or subcommand) dial to the right and you'll add lines toward the "-" side. This will make your next picture darker.

The more lines you add, the lighter or darker your next picture will be. If your photo is only a little too light or dark, then you probably just need to add a few lines in the appropriate direction. If your photo is way too light or dark, you'll have to add more lines to significantly affect the exposure. After you've adjusted the scale, take another picture and see if it looks better. Continue the process of taking pictures and adjusting the scale until you're happy with how the photo looks. Since it's a digital camera don't worry about taking multiple photos to get the right exposure, you can just delete the ones that didn't work!

AUTO MODES

The D90 offers a standard Auto mode and six Digital Vari-Programs (represented by the symbols on the Exposure Mode dial).

STANDARD AUTO

The Auto mode is the simplest exposure mode available. The camera controls most of the settings, giving you limited control. The D90 is truly in a "point-and-shoot" mode.

DIGITAL VARI-PROGRAMS

The Digital Vari-Programs are specialized auto modes in which the camera also controls most settings. The settings for each specialized mode are selected for photographing a certain type of subject or scene.

Flash Off.

In the Flash Off mode, the flash will not fire under any circumstances. This can be useful if you're not allowed to use a flash or there is low lighting but you don't want to use the flash. In this mode the camera focuses on the closest subject.

Portrait.

The Portrait mode processes the image to produce soft, natural-looking skin tones. The camera focuses on the closest subject and the flash is in auto mode. If your subject is far from the background and/or you're using a telephoto lens, the background will appear out of focus.

Landscape.

The Landscape mode makes the greens and blues in your scene more vivid. The camera focuses on the closest subject and the flash is turned off.

Action.

The purpose of the Action mode is to freeze action by using a fast shutter speed. To keep track of a moving subject the camera continuously focuses and the active focusing point will move to follow the subject. The flash is turned off.

Close-up.

Use for close-up pictures of small objects such as flowers, insects, and jewelry. The camera focuses on what is in the center of the view-finder. The flash is in Auto mode.

Night Portrait.

The Night Portrait mode is for photographing a person when there is low lighting. The purpose of this mode is to balance the light on the person with the light in the background. The camera will focus on the closest subject. The flash is in Auto mode, but it will likely fire since you're using this mode in dim lighting. Due to the low light in the background the camera will require a slower shutter. As a result you'll want to have the camera on a tripod so that you get a sharp picture.

The Digital Vari-Programs such as Landscape can make it easy to grab a quick shot while you're traveling.

EXPOSURE MODES REVIEW

Auto mode is best for when you need to take a shot as quickly as possible and want the camera to take care of everything for you. The Digital Vari-Programs are useful Auto modes for photographing specific types of subjects. Program mode gives you more control over your settings, but the camera still picks the aperture and shutter speed for you. Aperture Priority and Shutter Priority are good choices if you're looking to move away from Program or Auto because they allow you to control either the shutter speed or aperture component of your exposure. Manual mode puts you in control of both the aperture and shutter speed.

EXPOSURE COMPENSATION

Does the camera always get the exposure right? No. So what can you do when you take a picture and it's too light or too dark? Use the indispensable exposure compensation setting! Exposure compensation allows you to force the camera to make an exposure that's lighter or darker than the camera thinks it should be. To use exposure compensation press and hold the D button on the top of the camera, then turn the command dial left or right to set the amount of exposure compensation. The number on the control panel will change. Turn the dial to the left to make the exposure lighter, turn it to the right to make it darker. The number range goes from +5.0 to -5.0. Numbers in the "+" range will make your photos lighter, photos in the "-" range will

make it darker. You can also make the same adjustments while looking at the shooting information display or through the viewfinder. In the viewfinder you'll see the exposure compensation info $(+/-\ 0.0)$ at the bottom right.

Initially you'll probably use the exposure compensation after you've taken a picture and need to make an adjustment and take the same photo again. Though once you become familiar with how the D90 performs in different lighting situations, you may be able to anticipate when you'll need exposure compensation. In these cases you can set the exposure compensation even before you take the first picture. It'll save you some time and put you closer to getting the shot you want the first time.

Extremes of light and dark can make for challenging exposures. Use exposure compensation to make sure you get it just right.

Here are a few things you'll definitely want to remember about exposure compensation:

- Exposure compensation will only affect the exposure of future pictures you take. It will not change a picture you have already taken. So if you're not happy with how light or dark a picture is, adjust the exposure compensation and then retake the photo.
- Exposure compensation will not reset itself automatically (even when you turn the camera off). After you take a picture using exposure compensation, set the compensation amount back to zero. This is a good habit to get into because then you won't be making future pictures lighter or darker by accident.

- Exposure compensation can only be used in the P, S, or A exposure modes. You can change exposure compensation in the Manual (M) exposure mode. However, it won't have any effect because you control the aperture and shutter speed in Manual. No exposure compensation adjustments can be made in the Auto or Digital Vari-Program modes.
- You will also see this same scale and numbers inside the viewfinder.

BRACKETING

Bracketing is another feature of the D90 related to exposure. Exposure bracketing is when a series of pictures is taken and the exposure for each photo is different. What you end up with is a range of exposures from lighter to darker of the same composition. This was particularly helpful with film photography when there was a tricky lighting situation and you weren't sure what the best exposure would be. You could bracket and better your odds that at least one exposure would be usable. I don't find bracketing as necessary with digital photography. In most situations you can take a shot, then see how it looks on the monitor. If it's too light or took dark you can dial in the necessary exposure compensation and go from there. You may find bracketing more useful for specific applications such as HDR (High Dynamic Range) Photography where you combine a series of lighter and darker exposures.

To access bracketing you're going to press and hold the w bracketing button while turning either the command or sub-command dial.

Here's what you'll see initially (no adjustments to bracketing):

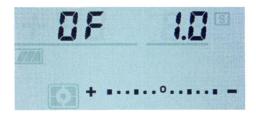

The top left number, initially a zero, is going to tell you how many photos are going to be taken in the bracketing sequence. Turn the command dial to the left or right to change this number.

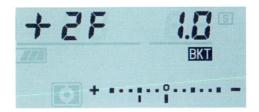

Two photos will be taken: the first at the camera's initial meter reading, the second one stop lighter.

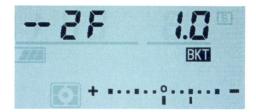

Two photos will be taken: the first at the camera's initial meter reading, the second one stop darker.

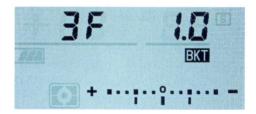

Three photos will be taken: the first at the camera's initial meter reading, the second one stop lighter, the third one stop darker.

How do I know the second or third photos are going to be one stop light or darker? That's where the second number on the display comes in. The number in the top right is the amount of exposure difference between the bracketed exposures. "1.0" is one stop.

0.3 is one-third stop

0.7 is two-thirds stop

DEPTH OF FIELD PREVIEW BUTTON

The depth of field preview button is located on the front of the camera near the bottom of the lens. If you press and hold it down while looking through the viewfinder you'll see the area behind your subject become more distinct. The effect will be more apparent if you're using a telephoto lens and have the aperture set to about f/11. While you're holding the button down you're seeing a preview of how sharp/distinct your photo will be when you take the shot. I like to use it to preview what the background will look like when I'm doing close-up photography. Try using the button with the aperture set to different numbers as you'll see a different effect on the background. The viewfinder also becomes darker, but don't worry that doesn't mean your photo will be underexposed.

IMAGE QUALITY

In addition to selecting the appropriate shooting mode to make sure you capture the peak of the action, the fleeting moment, or the incredible light, you want to also have a high-quality digital image. You can find the image quality information in the control panel or in the shooting information display. To adjust the image quality press and hold the 🕲 button, then turn the command dial. Here are all the quality options you'll cycle through:

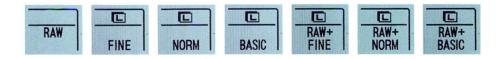

There are two types of file formats you can choose from on the D90: JPEG and RAW. A JPEG is the common file format for photos. If you've used a compact digital camera it was saving your photos as JPEGs. If the D90 is your first digital SLR camera, then it's likely your previous cameras haven't had the option to shoot in a RAW format. I'll discuss the RAW file format in more detail after we look at JPEGs.

The JPEG quality options are Fine, Normal, and Basic. Fine is the highest quality JPEG setting and Basic is the lowest. JPEGs have relatively small file sizes because they are a compressed file format. This means when a JPEG is saved some amount of digital information about the photo is thrown away to make the file smaller. Fine JPEGs are compressed a little, Normal JPEGs are moderately compressed, and Basic JPEGs are significantly compressed. The more compressed a JPEG is, the more information is thrown away and the lower the quality of the resulting image.

As you move from one quality option to another notice that the number to the right changes. The number tells you how many more pictures can fit on your memory card at that setting. Fine JPEGs are a much larger file size than Basic JPEGs. As a result you can fit many more Basic quality photos on a memory card than you can Fine quality. At first it might seem like a good thing that you can fit many more photos on one memory card. However, that lower file size (which equals more photos) reflects a much lower quality image. If you photographed at the Basic setting the quality of your photos may only be good enough for e-mailing and putting on a Web site. Your printing options would be very limited. I suggest using the Fine setting all of the time to give yourself the most flexibility. You may not be thinking about making a print right now, but it's nice to have the option later on. The hard drives in our computers keep getting bigger, so storing a large number of high-quality photos isn't likely to be a problem.

You'll also see three options that list RAW plus either Fine, Normal or Basic. If you choose one of these settings then every time you take a picture the D90 will record a RAW file and a JPEG. Recording two files at once will fill up your memory card faster, but you'll have both file formats available from the start.

If this picture had been taken at the Basic JPEG setting, the quality would be too low to make a nice print to hang on the wall.

A RAW file is a completely different file format than a JPEG. It certainly has its benefits, but there are drawbacks as well. A RAW file is not a standard file format. Each camera manufacturer has its own proprietary RAW format. Nikon's RAW files are called NEFs because NEF is the file extension. For example, DSC_0928.NEF. A RAW file

gives you more control over adjusting your photo after it's on your computer. You can adjust settings such as exposure, contrast, saturation, and white balance and still retain an excellent quality image. You can also bring back detail in areas of a photo that have been over- or underexposed. In comparison, the more significant adjustments you make to a JPEG on the computer, the greater potential for a loss of image quality.

To view and make these adjustments to a RAW file you need software that can read RAW files. In comparison, JPEGs are a common file format so most software programs can be used to view them. A variety of manufacturers make RAW processing programs. Nikon's software is called Capture NX and it is discussed in Part II. Other RAW processing programs include Aperture by Apple, Lightroom by Adobe, Capture One by Phase One, and Adobe's Camera Raw plug-in for Photoshop and Photoshop Elements. The programs vary in what features they offer, but they can all adjust RAW files. The greatest benefit to RAW files is the level of control you have in adjusting them after the fact. The downside is you need extra software, it requires more time in front of the computer, and the files are larger.

IMAGE SIZE

The Image Size setting is available if you selected one of the JPEG options in Image Quality. Image Size options don't apply to RAW files. You can find the image size symbol in the control panel or in the shooting information display. It's located just above the quality setting. To select the image size press and hold the button, then turn the sub-command dial.

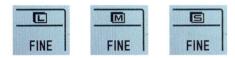

The Image Size options are Large, Medium, and Small. As with the quality setting, image size also affects what you can do with your photo. With a smaller image size there are less pixels recorded. The fewer the pixels the less information in your picture. This limits how large a print you could make of that photo. Stick with the Large size to retain the most detail in your photo.

ISO

The ISO setting refers to how sensitive the sensor is to light. When we used film cameras we'd photograph with different speed films. ISO is the digital equivalent of film speed. The higher the ISO, the less light the camera needs to make a good exposure. With higher ISOs you can use faster shutter speeds or smaller apertures while still achieving a proper exposure.

SETTING THE ISO

The ISO information is not part of the standard information shown in the control panel. Here are two ways you can check the ISO setting. First you can hold down the button and look at the control panel. Second you could press the button to bring up the shooting information on the monitor. The ISO is listed in the bottom right.

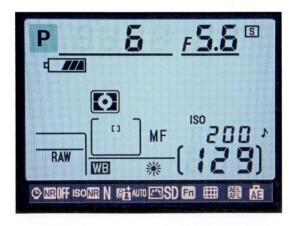

To change the ISO press and hold the button, then turn the command dial.

The ISO range goes from 200 to 3200, plus L 1.0 (ISO 100 equivalent) and H 1.0 (ISO 6400 equivalent). It might seem like a great choice to always go with a high ISO because then you won't have any problems with freezing moving subjects or using small apertures. Unfortunately there is a downside to using high ISOs. High ISOs cause a loss of fine detail (hair, for example) and give a mottled appearance to areas with a solid color (such as a blue sky). This is called noise. Noise is also more noticeable in dark areas of a photo.

To avoid noise it's best to use the lowest ISO possible. If you're outside on a sunny day photographing landscapes use ISO 200. If you need to stop fast action try ISO 400 or 800. Also if you go inside where the lighting is not as bright, ISO 400 or 800 are good choices. I would caution against regularly using ISO 1600, 3200, and especially HI 1. If you need those high ISOs in certain situations it's great that they're available, but they don't offer the best image quality.

Here's an example of how a higher ISO can allow you to use faster shutter speeds or smaller apertures. Let's say the correct exposure for your picture is f/4 at 1/30 of a second.

Here's how the shutter speed would increase if you used higher ISOs (aperture stays the same):

ISO	Shutter Speed
200	1/60
400	1/125
800	1/250
1600	1/500
3200	1/1000

Here's how the aperture would change if you used higher ISOs (shutter speed stays the same):

ISO	Aperture
200	f/5.6
400	f/8
800	f/11
1600	f/16
3200	f/22

As you can see from these examples, you could use a significantly faster shutter speed by changing the ISO. This is very important if you're trying to capture kids playing sports or other fast action. On the other hand, you could raise the ISO to use a smaller aperture if you're traveling and want to capture all the detail in a landscape.

At high ISOs noise can be noticeable in dark areas of a picture.

AUTO ISO

The D90 also offers an Auto ISO option. Auto ISO will automatically raise or lower the ISO to help you achieve a correct exposure. This can be a useful setting if you don't want to have to remember to change the ISO when you go from bright light outdoors to dim lighting indoors.

Auto ISO is set through the Shooting Menu. Press the we button and use the multi selector to move down to the Shooting Menu.

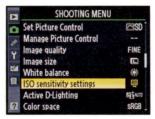

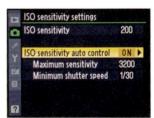

There are two other options for auto control: "Maximum sensitivity" and "Minimum shutter speed." These settings give you the ability to set some parameters on the ISO as well as shutter speed, which makes Auto ISO more useful. Max sensitivity lets you choose the highest ISO to be used. This is helpful if you don't want the camera to go to ISO 3200 because of noise/quality issues, instead you can set it where it works best for you.

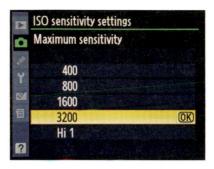

Min shutter speed allows you to set the slowest shutter speed. You can use this setting to make sure the camera doesn't pick too slow a shutter speed for you. If you're hand-holding the camera you may not want the shutter speed to go below a 1/30 or 1/60 of a second, because it'll be harder to hold the camera still enough to get a sharp shot.

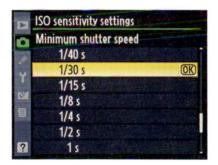

METERING

Metering refers to how the camera is reading the light on your subject or scene. The D90 has three metering options that determine how the camera uses this information to set the exposure. You can find the metering mode symbol in the control panel or in the shooting information display.

To choose the metering mode press and hold the 🚳 button, then turn the command dial.

MATRIX

Matrix metering is a good all-purpose metering setting. The camera takes separate readings of the brightness and color from all parts of the scene in your viewfinder. This allows the D90 to take into consideration areas that are bright, dark, and in between.

© CENTER-WEIGHTED

Center-weighted metering places an emphasis on what is in the middle of the viewfinder. The camera takes a reading of everything in the viewfinder, but when calculating the exposure it gives more weight, or importance, to what is in the center of the image. This is a good option for portraits and other photos when your primary subject is in the middle. Particularly if the background is significantly brighter or darker than the subject, center-weighted metering will give more "attention" to your subject, and the exposure won't be thrown off by the background.

• SPOT

Spot metering is a very precise metering option. The spot meter reads one small area of the viewfinder and ignores everything else. In the viewfinder there are eleven small squares. These are the focus area boxes. The spot meter reads from whichever one of these is active. The active box is the one with the rectangle surrounding it. You can press left/right or up/down on the multi selector to change which box is active.

With such a bright background the camera's meter could easily be thrown off. Using a spot meter controls what part of the image the camera was measuring.

RELEASE MODES

There are a few shooting modes to choose from. The different modes give you the option to take pictures one at a time or continuously, as well as the option to use a self-timer or remote control. You can find the release mode symbol in the control panel or in the shooting information display.

To choose the release mode press and hold the button, then turn the command dial.

SINGLE-FRAME

In the single-frame release mode the D90 will take one picture each time you press the shutter release button. Even if you continue to hold down the shutter release button, the camera still only takes one picture. To take additional photos you need to lift up your finger and press the button again. This is the shooting mode you'll use for most photos.

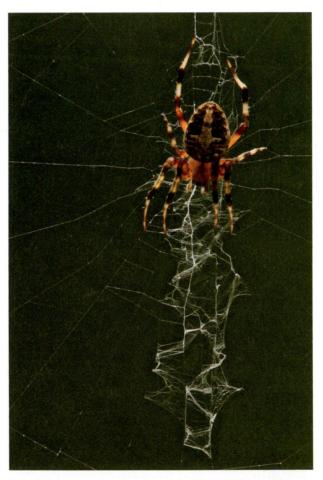

This spider was a cooperative subject, as it sat still in the middle of its web.

3fps 4.5fps CONTINUOUS

The D90 has two continuous release modes: low and high. When using either mode the camera will take pictures without stopping as long as you keep the shutter release button pressed down. In the high

(H) mode the D90 can capture 4.5 pictures per second. For the low (L) mode you can choose how fast it takes pictures (from 1 to 4 pictures per second), but that has to be set through the Custom Setting Menu. The continuous shooting modes are great for capturing action. It's difficult to take a single action photo and freeze just the right moment in the action sequence. By shooting a burst of photos you're more likely to capture at least one good photo in the series. Whether you want to use continuous low or high just depends on how fast a burst of pictures you want to capture.

Setting Continuous Low: Press the button and use the multi selector to move down to the Custom Setting Menu.

Select the shooting speed you want and press OK.

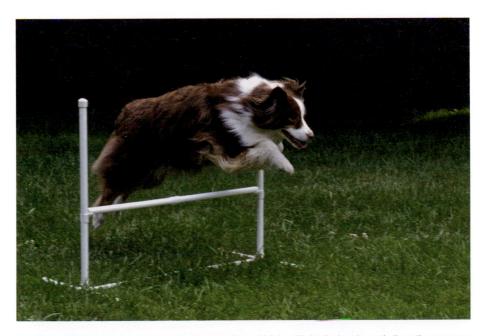

Shooting a continuous burst gave me a series of photos from which I could pick the best image in the action sequence.

The D90 has a memory buffer that temporarily stores your photos before they are saved to the memory card. In the continuous shooting modes this buffer allows you to continuously take pictures while the camera is saving photos to the memory card. Think of the buffer as a waiting area for photos before they are moved to the memory card. This waiting area only has so much space, so depending on the size of the picture files it could fill up quickly. If the waiting area (buffer) fills up then the camera can't take another photo until it's moved a picture from the buffer to the memory card. If the camera pauses because of this, keep the shutter release button pressed down and the camera will start taking pictures again as soon as it's able.

The good news is if you're shooting JPEGs the buffer is unlikely to fill

up and you won't have any problems capturing a long burst of action. If you're capturing images in the RAW file format, then the buffer can fill up after about 10 pictures and there will be a lag between photos.

SELF-TIMER

The self-timer is useful for self-portraits or group photos that you want to be in. You'll want to have the camera on a tripod or other stable platform. The default timer delay is 10 seconds. You can change the length of the self-timer delay in the Custom Setting Menu (Part I: Section C). Delays of 2, 5, 10, or 20 seconds are available. After you press the shutter release button, the lamp on the front of the camera will flash as the timer counts down, then stay lit up for the last couple seconds before the picture is taken. If you have the "beep" turned on, the D90 will also beep during the countdown, changing to a rapid beeping just before taking the picture.

DELAYED REMOTE

When the ML-L3 remote (see Part VI) is used in the delayed response mode, the D90 will wait for two seconds, then take the picture. The lamp on the front of the camera will stay lit for the two seconds and the camera will beep (unless the beep option has been turned off). Using a remote makes it easy for you to get into a group picture, then just press the button when everyone is ready. A remote can also be useful for taking a self-portrait.

QUICK-RESPONSE REMOTE

When using the quick-response mode there is no delay. The D90 will take a picture when the button on the ML-L3 remote (Part VI) is pressed. After the picture is taken the camera will beep (unless turned off) and the lamp will flash once. This mode is helpful for

avoiding camera shake. Also, it's useful if you can't be right at the camera when taking the picture. For instance, maybe you want to hold a colorful piece of fabric behind your subject. Using the remote you could position the fabric in the background and take the picture at the same time.

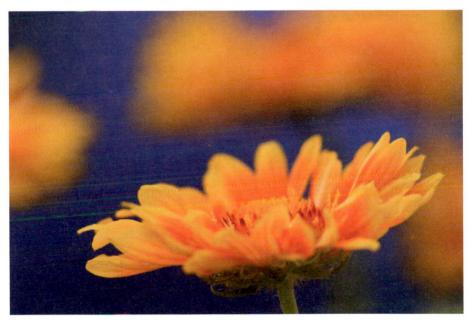

A piece of blue fabric was held behind a cluster of flowers to create a colorful background that complemented the subject.

REMOTE ON DURATION

The D90 will wait for a signal from the remote control (Delayed or Quick-response remote modes) for one minute (default setting). If one minute passes and the remote has not been used, then the camera will reset to the single or continuous shooting mode, whichever was used last. You can set a longer period of time before the remote mode is cancelled in the Custom Setting Menu (Part I: Section C).

CAMERA SHAKE

The self-timer and remote control settings can also be used to reduce the possibility of camera shake. Even with the camera on a tripod, you may slightly shake the camera when you press the shutter release button. This can lead to a lack of picture sharpness even when the subject is in focus. Using the self-timer or a remote ensures that you are not touching the camera when it takes the picture. If you're using the self-timer or delayed remote, make sure your subject isn't moving;

otherwise you won't know where the subject will be when the picture is taken.

AUTOFOCUS MODES

The autofocus modes control how the autofocus system functions. You can find the autofocus mode displayed in the control panel or in the shooting information display.

To choose the autofocus mode press and hold the $^{\textcircled{4}}$ button, then turn the command dial.

Type of Photo	Suggested Focus Mode
Subject is not moving	AF-S or Manual Focus
Action shot	AF-C
Close-up/macro	Manual Focus

AF-A AUTO-SERVO AUTOFOCUS

Auto-Servo autofocus mode chooses between single (AF-S) and continuous (AF-C) autofocus modes. The camera will sense if the subject is still or moving, then pick the appropriate autofocus mode.

AF-S SINGLE-SERVO AUTOFOCUS

Single Autofocus is good for subjects that are not moving. Press the shutter release button down halfway to lock the focus on your subject. The D90 will stay focused on the subject as long as you keep the button pressed. Practice pressing and holding the shutter release button to get a feel for how hard to press the button to lock focus, but not hard enough to take a picture. While you have the focus locked, try pointing the camera at other objects. Point the camera at something behind your subject or even point it at your own feet. You'll notice that the camera doesn't refocus; the focus is still locked on your subject. However, if you or the subject moves (changing the distance from the camera to the subject), the camera won't refocus. If this happens you'll need to lift your finger off the shutter release then press it again to refocus on the subject.

If your subjects are not moving, Single Autofocus mode is a quick and easy way to make sure they're sharp.

AF-C CONTINUOUS-SERVO AUTOFOCUS

Continuous Autofocus is a great focusing mode when photographing something that is moving such as a person or an animal. When you press the shutter release button halfway, the camera focuses on the subject in the active focus bracket. In AF-C mode the camera doesn't lock focus because it will continually refocus as the distance between you and your subject changes. Let's say you're photographing a person. If you walk toward the person the camera will adjust focus to keep the subject sharp. The same holds true if the person walks toward or away from you.

Use Continuous Autofocus to keep a moving subject in focus.

MANUAL FOCUS

To use manual focus just flip the AF/M switch on the left side of the camera.

In Manual Focus mode you control where the camera focuses by turning the focusing ring on the lens. If autofocus can't lock onto your subject try using manual focus instead. Manual focus is also a better choice for close-up or macro photography. When you are photographing something small it is important to be able to precisely place your point of focus. Autofocus often won't "choose" the right place to focus in these situations.

Using Manual Focus allowed me to carefully focus on the first group of water droplets.

FOCUS INDICATOR

In the viewfinder there is a very helpful symbol called the focus indicator. It's a green circle on the far left of the viewfinder. This circle is only visible when something is in focus. When you're using autofocus the camera will beep and the circle will appear when the subject is in focus. Even if the beep is turned off, the circle will still appear to let you know your subject is in focus. If autofocus cannot lock onto what's in the focus bracket the circle starts blinking.

The focus indicator can also be a big help in the Manual Focus mode. You can use the indicator to check and make sure the most important part of your subject is in focus. Use the multi selector to choose the

focus bracket that is over your subject. Then turn the focusing ring on the lens until the circle appears. If more than one focus bracket covers your subject, select the bracket that has the most important part of your subject.

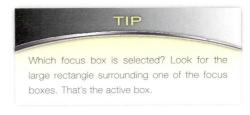

AUTOFOCUS AREA MODES

In the viewfinder there are eleven small squares in the center area. Each square is a focus area. When using autofocus (described in the previous section) the D90 will focus on the subject in one of these boxes. The autofocus area modes control how the boxes are used by the autofocus system. These settings have no effect in the manual focus mode. You'll want to start by selecting one of the autofocus

boxes. A black rectangle surrounds the selected focus box. Select the box where your subject is located. Press left/right or up/down on the multi selector to move the black rectangle to the desired box.

To change the autofocus area mode you'll need to go to the to move down to the Custom Setting Menu.

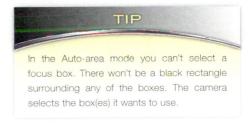

Custom Setting Menu. Press the button and use the multi selector

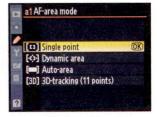

Select the autofocus area mode you want and press OK.

SINGLE POINT

In Single Point mode the camera will not change the focus box you select. This mode is good for subjects that are not moving.

DYNAMIC AREA

Dynamic Area is a great mode for photographing action. You use the multi selector to choose the focus area where your subject is located. Keep the shut-

ter release button pressed halfway down. If your subject moves out of that focus area the camera will switch to a different focus area to track your subject and keep it sharp. For the dynamic area mode to work effectively, your subject needs to stay somewhere within the area covered by the focus boxes. When using Dynamic Area set your autofocus mode to AF-C or AF-A. If you are in autofocus mode AF-S Dynamic Area will not track a moving subject.

AUTO-AREA

When using Auto-area mode the camera automatically selects the subject, often the closest thing to the lens. Your subject needs to be in one of the focus boxes.

3D-TRACKING

3D-Tracking mode is useful when your subject is not moving or moving very little. This mode allows you to focus on your subject then recompose the picture (keep the shutter release button pressed halfway down). The camera keeps track of your subject and makes sure it stays in focus. You'll see the black rectangle actually move to a different focus box, in order to keep the rectangle on the subject. This doesn't happen in any other autofocus area mode. Use 3D-Tracking modes with autofocus modes AF-A or AF-C.

The different modes are also indicated by a change in the display of the brackets on the monitor.

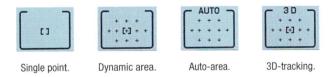

AUTOFOCUS CHALLENGES

Autofocus doesn't work perfectly at all times. Here are some situations when it may not perform as expected:

- Dim lighting: in low light situations there is less contrast, making it harder for the autofocus to lock onto a subject.
- Low contrast: subjects that are one color and have little or no detail, such as a piece of fabric or a wall.

- Fine detail: a repeating subject that is small and does not have a lot of variation, a field of wildflowers for instance.
- Small subjects: if the subject is small enough that it doesn't fill one of the focus boxes, the camera may focus on the background instead of the subject.

FOCUS LOCK

Sometimes you'll want to compose a picture where the subject is not in one of the focus boxes. So how do you use autofocus to focus on the subject? Use focus lock! Focus lock allows you to make sure the subject is in focus, while still keeping the composition you want. Here's how to do it:

- 1. Set the Autofocus Area mode to single, dynamic or 3D-tracking.
- 2. Place your subject in the active focus box.
- 3. Press the shutter release button halfway to lock the focus on your subject (check for the focus indicator circle in the viewfinder). As long as you keep the shutter release button pressed halfway your subject will stay in focus.
- 4. Recompose to place your subject wherever you want, then take the picture. Now you have the composition you wanted and your subject is in focus.

It can take a little practice to get used to holding down the shutter release button and not accidentally taking a picture. Try practicing at home. Focus on an object, hold the shutter release to lock the focus, and then move the camera. If the focus stays locked on the object then you've got it!

After taking a picture with focus lock, if you keep the shutter release button pressed half-way down, the focus will still stay locked on your subject. The trick here is to not lift your finger all the way up after taking the photo. The natural reaction is to take your finger off the shutter release after taking the picture. You'll have to "retrain" your finger to stay on

TIP

USING THE AE-L/AF-L BUTTON

You can also lock the focus using the button on the back of the camera. Follow steps 1–3 above. Then while holding the shutter release button halfway down, press and hold the AE-L/AF-L button. You can now take your finger off the shutter release button, while still pressing the AE-L/AF-L button. As long as you keep this button pressed down the focus will stay locked. Recompose. When you're ready to take the picture press the shutter release button all the way down. The benefit of using the AE-L/AF-L button is you don't have to worry about accidentally taking a picture by pressing the button too

the button.

hard. However, if having to press two buttons seems too complicated just stick with pressing the shutter release button halfway.

Note: When you use the AE-L/AF-L button it also locks the exposure. If you just want it to lock the focus you can change this by going to #f4 in the Custom Setting Menu.

WHITE BALANCE

You'll be taking pictures under many different light sources: outside there is sunlight, at home you have lamps, and in an office there may be fluorescent lights. Every type of light has a certain color to it, but when we see things under these various light sources they still appear to be the correct color. A white piece of paper will look white to you whether you see it under a lamp or outside in the sunlight. As the color of the light source changes our brains are able to adapt.

Unfortunately our cameras aren't so lucky. They need a little help to avoid unattractive color casts from the various light sources. Have you ever seen a picture that has a strange color cast to it? Everything might look overly yellow or have a tinge of green or blue. This is the result of the color of the light having an effect on the entire picture. With film cameras this was more of a challenge because you had to use certain types of film or special filters to avoid these color casts. With digital cameras the white balance setting makes it pretty easy to avoid these potential problems.

You can find the white balance mode displayed in the control panel or in the shooting information display. To change the white balance mode press and hold the button, then turn the command dial.

There's an auto setting and six settings for specific types of lighting. In addition you can choose a color temperature yourself or use the preset option to set a custom white balance. This might seem like a lot of choices, but picking the right white balance is actually pretty easy. Just ask yourself: "What type of lighting am I under?" Then choose the setting that matches that type of lighting. For example, if you're outside and it's sunny, choose * (direct sunlight). If you're inside your house pick * (incandescent). When you're using the flash select (flash). It's that easy!

MIXED LIGHTING

Sometimes you'll find there is more than one type of light on your subject/scene. Mixed lighting can be more challenging. How do you know which white balance to pick? In these situations Auto White Balance is a good choice because it can set a white balance that takes the different light sources into account.

AUTO AUTO

When using Auto White Balance the camera sets the white balance for you. Like other auto modes, Auto White Balance is convenient because the camera does the work for you. If you go from photographing outdoors to taking pictures inside your house, the camera automatically changes the white balance. The Auto setting might not always produce perfect results. You may photograph in certain lighting situations where it doesn't produce the results you want. This doesn't mean you can't use Auto White Balance. Just remember what those conditions are and choose another setting in those situations.

* INCANDESCENT

Incandescent/tungsten is the type of lighting you'll most commonly find at home.

#4 FLUORESCENT

Fluorescent lighting is often found in businesses and office buildings. Notice there's a number after the fluorescent symbol. This is because the D90 offers multiple types of fluorescent lighting you can choose from. You have to go to the Shooting Menu to select a different fluorescent white balance setting. Press the button and use the multi selector to move down to the Shooting Menu. Go to the White Balance menu item, then select Fluorescent.

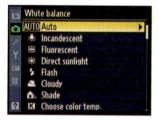

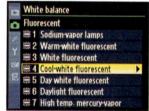

Select the fluorescent setting you want and press OK.

*** DIRECT SUNLIGHT**

For use on sunny days.

FLASH

Use the flash setting when your primary light source is the flash on your camera (or an external flash unit).

CLOUDY

On overcast days use the cloudy setting. If you use the direct sunlight setting on a cloudy day your pictures will have a slight blue color cast. The cloudy setting warms up your pictures to get rid of that blue cast.

SHADE

It may be a sunny day, but if your subject is in the shade you'll want to set your white balance to shade. Shade is a stronger version of the cloudy setting. If the sky is a heavy overcast, the cloudy setting may not "warm up" your scene enough. Try shade for more natural colors.

CHOOSE COLOR TEMPERATURE

If there is a specific color temperature you want to use you can set it here. Use the sub-command dial to change the color temperature number 5000*.

PRE PRESET WHITE BALANCE

Use preset white balance in the following situations:

- 1. To set a custom white balance when the other white balance settings aren't producing the results you want; for example, if there is mixed lighting and you're not getting good results from the Auto setting, try setting a custom white balance
- 2. You want to copy the white balance setting from another photo on your memory card.

These preset options are through the Shooting Menu (see Part I: Section C).

To get a feel for how white balance can change a photo let's look at two sets of examples. For each set I've taken the same photograph, but applied different white balance settings to each image.

Direct sunlight.

Cloudy.

Shade.

Incandescent.

Fluorescent.

Flash.

The photos with the outside white balance settings (sunlight, cloudy, shade) are all noticeably warm. Fluorescent has a light magenta cast. Flash is warm as well because the color of light from a flash is similar to daylight. The incandescent photo is the most natural because the dining room was lit with incandescent light bulbs, even though you may think the sunlight photo makes a room feel more warm and inviting.

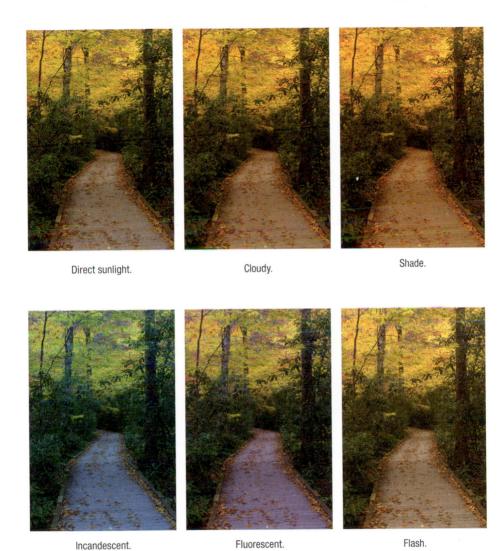

This photo was taken on an overcast day. The direct sunlight white balance renders the scene a little cool. The cloudy and shade photos both warm it up. Shade has a bit of a yellow cast, and is maybe a little too warm. Incandescent produces a blue color cast; fluorescent a magenta cast. As seen in the previous set of photos, the flash white balance is similar to direct sunlight. Depending on your taste, cloudy or shade would both be good options for this photo.

Part of choosing a white balance setting is personal taste. Should you use cloudy or shade? That depends on how warm you want your subject/scene to be. Perhaps you want to use the cloudy setting on a sunny day to add more warmth to your photo. Maybe you'll use the direct sunlight setting on an overcast day because you like the mood created by the cool tones. Feel free to experiment, you can always delete the photo later!

For more unusual results try using a white balance setting that is completely different than the actual lighting.

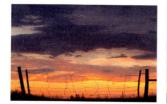

Direct sunlight.

Incandescent

Fluorescent.

For the sunrise image above the true colors are seen when the white balance is set to direct sunlight. The incandescent and fluorescent settings may not be accurate representations, but I think they're also good looking photos! Notice that the incandescent white balance adds a blue cast to the clouds that are gray in the direct sunlight photo. The fluorescent setting adds a magenta cast to the whole image.

FLASH

The built-in flash has different modes for use in different lighting situations. We'll look at what each mode does and when they would be used. Even though the flash has a lot of possible modes, you should be aware that they won't all be available depending on which exposure mode you're using (P, S, A,

M, 🖀, 🗷, 💟 or 🖾)

To change the flash mode press and hold the button, then turn the command dial. As noted above, your exposure mode will affect which flash modes are available.

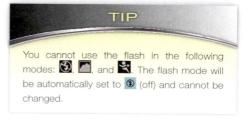

USING THE FLASH WITH THE TAND DIGITAL VARI-PROGRAM **EXPOSURE MODES**

In these modes the flash only pops up if the camera senses there isn't enough light for a proper exposure. In these situations the flash pops up when you press the shutter release halfway. The flash then fires when you take the picture.

DEFAULT FLASH SETTINGS

Auto flash is the default for and W.

Auto slow sync is the default for 🔼

USING THE FLASH WITH THE P. S. A. AND M EXPOSURE MODES

To pop the flash up in these modes you need to press the flash button on the left side of the camera. The flash will then fire whenever you take a picture. There is no "off" option in these modes. To make sure the flash doesn't fire press it down until it locks into place.

FLASH MODES

AUTO FLASH

The camera will fire depending on the lighting conditions. The flash will usually fire when the lighting is dim or when the subject is backlit (the light is coming from behind the subject, causing the subject to be much darker than the background).

FLASH ON

Flash will fire every time a picture is taken.

FLASH OFF

The flash won't fire under any circumstances.

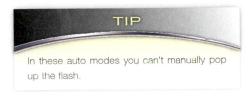

RED-EYE REDUCTION

Use red-eye reduction when photographing people. It won't eliminate red-eye in every photo, but it's worth trying. When the D90 attempts to reduce red-eye it lights up the autofocus assist lamp on the front of the camera for about one second before taking the picture. So be aware there will be this lag between when you press the shutter release and when the flash fires/picture is taken. This sequence will happen anytime you see the "eye" symbol next to one of the flash mode symbols.

- FLASH ON WITH RED-EYE REDUCTION
- AUTO FLASH WITH RED-EYE REDUCTION
- SLOW SYNC

The slow sync mode automatically slows down the shutter speed to capture detail in the background when there is low lighting or at night. This mode is good to use for a portrait in low light. The flash will fire and light up your subject then the shutter will stay open to allow detail to be recorded in the background. If you just used auto flash in this situation your subject would still be well lit, but the background would be very dark or even black. Since you'll be using this mode in low light at slow shutter speeds, you'll want to have the camera on a tripod or other steady platform. Otherwise you'll end up with a blurry picture.

- SLOW SYNC WITH RED-EYE REDUCTION
- AUTO SLOW-SYNC

The camera determines if the flash is needed. If the camera uses the flash it will be in slow sync mode.

- AUTO SLOW-SYNC WITH RED-EYE REDUCTION
- REAR CURTAIN SYNC

Normally the flash fires as soon you press the shutter release button. In the rear curtain sync mode the flash fires at the end of the exposure, right before the shutter closes. This mode can be used to create a trail of light behind a moving subject. This mode is best used in low light situations so that the exposure is long enough to give the subject time to move across the frame. If you use rear curtain sync with a fast shutter speed it may not look any different than using auto flash. This is because a fast shutter speed won't give time for the subject to move across the scene if the viewfinder.

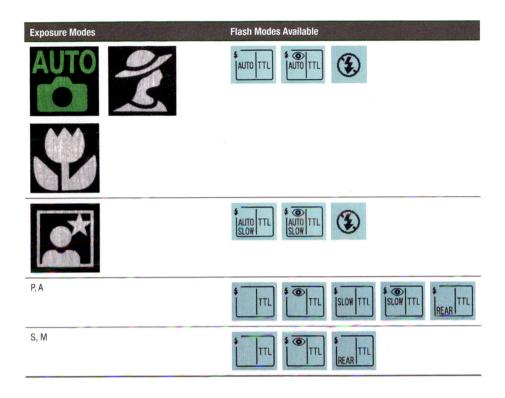

TIP

FLASH COMPENSATION

It's also possible to vary the power of the flash. You can increase or decrease the amount of light the flash puts out by using the flash compensation. The increased power of the flash is not enormous, but it does provide a little extra light if the normal flash power isn't quite enough. The D90 provides more options for decreasing the output of the flash. Flash compensation allows you to balance the light from the flash with the light in the rest of the scene. One of the problems with using the flash at its normal power is that the pictures will look like "flash pictures": the subject ends up very brightly lit, there's often a harsh shadow, and the background may end up very dark. Let's say you're photographing someone outside on a sunny day. The sun is hitting the person's face such that part of the face is brightly lit and

the other is a dark shadow. You could use the flash to throw some light onto the person's face to make the light more even and have less contrast. However, you wouldn't want to use the flash at its normal power because the light on the person's face would look unnatural. By reducing the power of the flash you can improve the lighting on the face, but not make it obvious that you used flash. That's the key to successfully using flash: making it look like you didn't use it!

To change the flash compensation press and hold the button then turn the sub-command dial. "0.0" is normal flash power. A positive number increases the power of the flash, a negative number decreases the power of the flash.

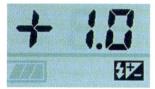

Regular flash power.

Decreased flash power.

Increased flash power.

Flash can be very useful when photographing people in bright sunlight. The flash lightens the heavy shadows resulting in a better looking photo.

No flash used.

Using flash lightens the shadows on the face.

LIVE VIEW

Live View is a great new feature of the D90 and it's very easy to use. To activate live view simply press the D button. The D90's monitor now shows what the lens is seeing. This is what you would be seeing if you were looking through the viewfinder instead of using live view. While live view is active you cannot see

TIP Flash tips:

- Flash compensation does not reset (return to 0.0) when the camera is turned off.
- · When the flash is used at a lower power it takes less time to recharge to be ready to take another picture.
- · Increasing the power of the flash will use more battery power and require longer for the flash to recharge.
- Flash compensation can be used to adjust the power of an external flash unit that is in the accessory shoe (SB-400, SB-600 and SB-900 flash units).

through the viewfinder because the mirror has been raised to allow the light to go back to the sensor. The sensor is used to show you the live view. Live view is useful when it's not convenient or possible to look through the viewfinder. Maybe you have your camera high up on a tripod or are holding it above your head. Use live view to help you position your camera and compose the picture.

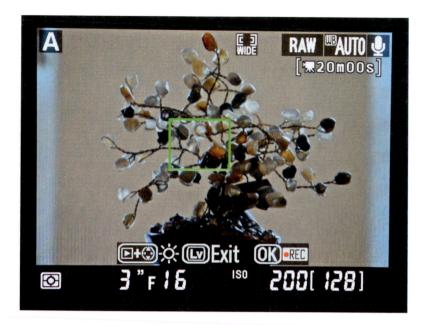

The numbers and symbols across the top and bottom of the monitor give you information about the camera's settings. The information across the top includes the following: exposure mode, autofocus mode, file format and white balance. Along the bottom is the metering mode, shutter speed, aperture, ISO and number of photos remaining. To exit live view press the button again.

You can use autofocus or manual focus in live view. The autofocus method for live view is not as fast as when you're shooting regularly. It can be particularly slow if your subject does not have a lot of contrast. There are three autofocus choices specific to live view which are listed in the Custom Setting Menu. To access these choices press the button and use the multi selector to move down to the Custom Setting Menu.

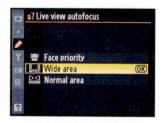

Autofocus Options:

• Face Priority: The camera detects faces in order to focus on the people in your photo.

- Wide Area: There is a focus box (see live view mode screen shot above) that you can move around to control where the camera focuses. Use the multi selector to position the box.
- Normal Area: Same as wide area, but the focus box is much smaller, for more precise placement of focus. Use the multi selector to move the box around.

Whether you are using autofocus or manual focus with live view you can zoom in on the live view screen to more accurately focus on your subject. Press the **1** button to zoom in and the **1** button to zoom out. Once zoomed in use auto or manual focus. When your image is focused you can zoom out, or take the picture while you're zoomed in. Even though you are zoomed in on the screen the image recorded will be the full view you saw on the monitor before zooming. Use the zoom ring on your lens for a wider or tighter composition.

RECORDING MOVIES

The D90 is the first DSLR able to record high definition videos. The video mode is part of live view which makes the video function easy to access. Press the button to switch to live view. Then when you're ready

to start recording a video press the button. That's it! A red circle flashes at the top of the monitor to tell you the camera is recording video. When you want to stop recording press the OK button again.

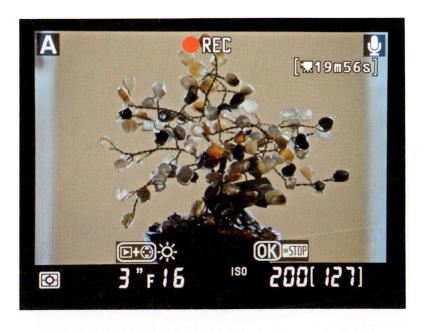

There are quality and sound options for movies in the Shooting Menu. To access these choices press the button and use the multi selector to move down to the Shooting Menu. The Movie Settings are at the bottom of the Shooting Menu.

You can choose whether to record sound during your movies. Quality Options

- All three settings record movies at 24 fps (frames per second).
- 1280×720: Highest quality, video proportion is 16:9
- 640×424: Moderate quality, video proportion is 3:2
- 320×216: Lower quality, video proportion is 3:2

Video Tips and Notes

- Be careful not to cover the microphone on the front of the camera while recording (located near the flash button).
- Focus on your subject in live view before starting the recording. Autofocus does not work while recording. However, you can still manually focus.
- When recording there's a countdown of the maximum time remaining in the top right of the monitor.
- Length of movie: 1280×720 movies can't be longer than five minutes. Movies taken at the other two quality settings can be up to twenty minutes long.
- The maximum size of movie files is 2GB. The movie will stop recording if your memory card fills up.
- Recorded movies appear in the playback mode along with your photos. Press the OK button to play them back.
- Matrix metering is always used no matter what metering mode you have selected.
- You can lock the exposure by holding down the AE-L/AF-L button while recording.
- Exposure compensation can also be used if you are in P, S, A or M exposure modes.

Section B: Viewing/ Reviewing Images

To view the photographs you have taken press the Playback button . A photograph will appear on the monitor on the

back of the camera. The D90 will display the last photo taken or the last image on the memory card. To exit Playback and switch to Shooting mode press or press the shutter release button halfway.

BROWSE IMAGES

Once you have an image on the monitor you can browse through all the photos stored on your memory card.

There are two ways to look through your photographs:

- 1. Press left or right on the multi selector.
- 2. Turn the command dial (back of the camera).

Besides using the Playback mode to look at your photographs, you can use it to find out a lot of information about your images. You can view up to seven screens of information in the Playback mode. To navigate through the information

screens press up or down on the multi selector or turn the sub-command dial (front of the camera).

Before we look at that information we need to change a setting in the Playback Menu so that you'll be able to see all those screens of information. By default the D90 only shows you a couple of the screens. This menu option lets you choose what other information you'd like to view.

Press the button and use the multi selector to move to the Playback Menu. In the Playback Menu go to the Display Mode item and press OK.

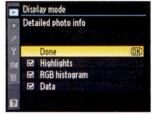

To display the Highlights, RGB Histogram and Data screens the boxes next to them need to be checked. Use the multi selector to move up and down the list, press the OK button as you highlight each item in the list. This will add the check mark. Most important, once you check all the boxes you need to go back up to "Done" and press the OK button to save the changes. Once that's taken care of press the button to return to the playback mode. Now let's take a look at what each screen tells us:

Basic Info:

On this screen you see an unobstructed view of your image. At the bottom of the monitor is some basic information about your photo:

- The name of the folder where the image is stored on the memory card
- File name of the image

- Image size (RAW, Fine, Normal, or Basic)
- Image quality (L, M, or S and resolution)
- Date the image was captured
- Time the image was captured

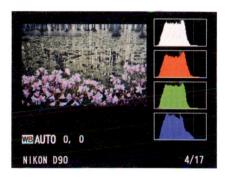

RGB Histogram

On the RGB histogram screen you can see your whole image, the white balance setting and four histograms.

The white histogram is the overall histogram. The histograms below are for the individual red, green and blue color channels. For this photo all the histograms are similarly shaped. However, that's not always the case and in those situations it can be useful to see a histogram for each color channel. I pay particular attention to the red histogram. If I'm photographing intense warms tones (reds, oranges, yellows) the red histogram can be clipped even if the overall histogram looks OK. Later in this section I'll discuss histograms in more detail.

Highlights

On the highlights screen you can see your whole image and at the bottom of the monitor is the word "Highlights."

This is an incredibly useful screen because it warns you if parts of your image are overexposed. Any areas that are continually blinking "black then white" are overexposed. A blinking area means that part of the picture is so bright that some detail has been lost. To correct for this overexposure use the exposure compensation button \bullet . Set the exposure compensation to a negative number then take the picture again. If there is a small area blinking try an exposure compensation of -0.3 or -0.7. If you have a large blinking area start with -1.0. Recall that exposure compensation only affects future pictures you take, not pictures you've already taken. After taking another photo, check the Highlights screen. If there are still areas blinking reduce the exposure compensation again. Continue this process until there are no more blinking areas.

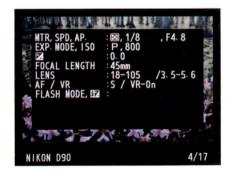

Detail 1

On this screen you'll find details about the exposure and the equipment you used to take the photograph. This information appears in a box overlaid on your image.

You'll find the following information:

- Metering mode
- Shutter speed
- Aperture
- Exposure mode
- ISO
- Exposure compensation (+/-)
- Focal length
- · Lens used
- Mode of autofocus (or M if manual focus was used)
- If VR was on or off
- Flash mode (blank if the flash was not used)

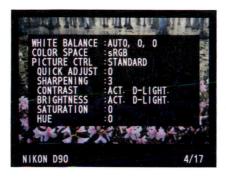

Detail 2

On the second details screen is information about the settings used to capture the image. This info also appears in a box overlaid on your image.

Here's what's listed:

- White balance mode and any compensation made to the preset white balance (+/-)
- Color space
- Picture Control the following items are settings for Picture Control
- Quick Adjust
- Sharpening
- Contrast
- Brightness
- Saturation
- Hue

The quick adjust, sharpening, contrast, brightness, saturation and hue settings can be changed in the Shooting Menu, under Set Picture Control.

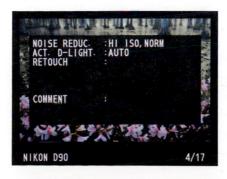

Detail 3

The third (and final) details screen just has a few pieces of information. The info is still in a box overlaid on your image.

Here's what's listed:

- Noise Reduction: If noise reduction was applied to the image
- Active D-Lighting: If this feature was on or off
- Retouch: If you're looking at an image created through the Retouch Menu, the type of retouching will be listed.
- Comment: Blank if no comment was added

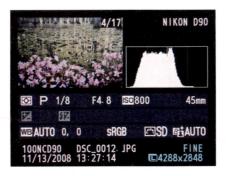

Overview

The overview screen displays your photo, an overall histogram and the basic exposure and shooting settings.

The histogram is a graph of your exposure. It shows how the light and dark tones in your image are distributed. It's an important tool for evaluating whether your image is too dark or too light. If you are outside on a sunny day or in dim lighting conditions, the image on the LCD may not be accurately show you how bright or dark the image actually is.

One important thing to remember is that there is no ideal shape for a histogram. As you look at the histograms for your photos, you'll see them in all sorts of shapes and sizes. Let's take a look at what the histogram tells you. The left side of the histogram represents the shadows and dark tones of your image. The right side represents the highlights and light tones in your photo. In the center are the mid-tones.

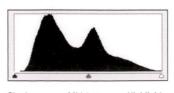

Shadows

Mid-tones

Highlights.

Initially you should pay the most attention to the shadows and highlights. When analyzing your histogram take a look at how it's distributed from left to right. The height of the histogram and the shape of the various peaks and valleys are unimportant when determining if vou have a correct exposure. There are two main things to look for when reviewing the histogram:

1. You want to avoid having part of the histogram all the way against the right side of the histogram box. This is called clipping the highlights. It means that some of the brightest areas in your image are not just very light, but have become completely white. There is no detail in these areas.

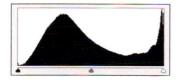

Loss of detail in the highlights.

2. You also want to avoid having part of the histogram all the way against the left side of the histogram box. This is called clipping the shadows. It means that some of the shadow areas in your image are not just dark, but completely black. There is also no detail in these areas.

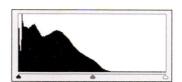

Loss of detail in the shadows.

In situations when there is a lot of contrast in your subject or scene (bright highlights and dark shadows), you may not be able to avoid either clipping the highlight or shadow detail. In these cases you have to decide which is more important: keeping details in the highlights or the shadows. I usually choose to hold the detail in the highlights and sacrifice the shadow detail. If your highlights are overly bright they can become a distraction. The bright areas will draw the eye away from your subject because someone looking at your picture may pay more attention to the bright area(s). On the other hand, shadow areas are already dark. So I find it more acceptable to allow them to become a bit darker.

LOSING DETAIL

What does it mean if "details are lost"? Consider if you took a landscape picture with puffy white clouds in the sky. Then you went to the Highlight screen in the Playback mode and the clouds were blinking. This means the clouds are now large areas of pure white. The clouds won't look puffy with delicate texture because they've lost all their detail. They'll simply be empty masses of white in your picture.

Let's look at histograms in a little more detail. I mentioned above that the peaks and valleys of the histogram aren't related to correct or incorrect exposure. The height of the peaks show you how much of a certain tonality is in your photograph. As seen in the histogram below, between the highlights and the mid-tones are the light tones; between the shadows and the mid-tones are the dark tones. Looking at the histogram you can tell that the photo it represents has a lot of dark tones because there is a tall spike in that section. There are a moderate amount of mid-tones and smaller amount of light tones, which you can see from the height of the spikes.

Shadows Dark tones Mid-tones Light tones Highlights.

Here's the photo for this histogram. As you can see the light and dark areas in the photo match the histogram.

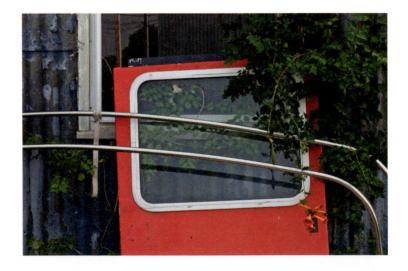

The next histogram has a different arrangement of peaks and valleys. The photo represented by this histogram has many light tones and dark tones, but not many mid-tones.

Shadows Dark tones Mid-tones Light tones Highlights.

Here's the photo for this histogram. Once again the light and dark tones in the photo match what is seen in the histogram.

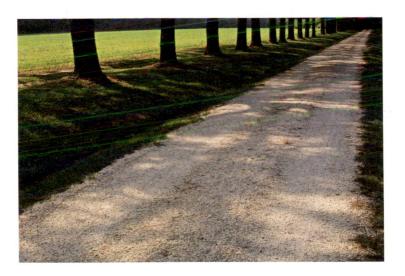

PLAYBACK SUMMARY

The basic info screen is good for viewing your photos and showing them to others. The highlight and overview screens are useful for evaluating your exposure. These are the two screens I check after taking a photo to make sure the exposure is correct. The RGB Histogram screen provides more in-depth histogram information. The three detail screens give you the technical information for your image. This may be more information than you ever want to know about your photos, but it's there if you need it! This information is actually part of the image file that is saved on your memory card. Using the software we'll look at in Part II you can see this information again after you put the pictures on your computer. This is convenient, because at a later date you may want to look up a certain setting such as what aperture you used or what the ISO was set at. You can even find out on what date you took a photo. No need to remember when you visited a certain place, you can just use the software to look up the date for a photo you took there.

DELETING PHOTOS

While in Playback mode you can delete photos by pressing the trash button . The following message will appear to confirm that you do want to delete that photo:

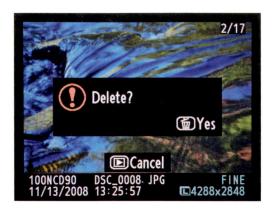

Press again to delete, press to cancel and return to your photo.

PROTECTING PHOTOS FROM DELETION

If you want to make sure you don't accidentally delete a particular photo, press the button while in Playback mode. A key symbol will appear in the top left of the photo.

The camera won't let you delete a protected photo. To remove the protection press a second time and the key will disappear.

ZOOMING IN

To zoom into your photos during playback press the 🕲 button. Each press of the button will zoom in further until you are looking at a very small part of your photo. To zoom back out press the button.

As you zoom in or out a thumbnail of the entire image appears on the monitor. The yellow box shows you what part of the image you're looking at. To see different areas of the magnified photo press left, right, up, or down on the multi selector. The yellow box will move as you press the multi selector to help you navigate around the photo.

Viewing different parts of the magnified photo.

If you don't press any buttons for a couple of seconds the thumbnail image will disappear. It will reappear once you zoom in or out or use the multi selector to move around the photo.

The zoom feature is a convenient way to see the details in

your photos. However, when making critical decisions about image sharpness, I don't recommend using it to choose which photos to delete. On one hand, if a photo is significantly out of focus that will be easy to see. On the other hand, if a photo doesn't appear quite

sharp, I wouldn't delete it based on how it looks on the monitor. Wait until you can see the photo on your computer to make a final determination. Your computer monitor is much better quality than the D90's monitor and will allow you to better assess sharpness.

VIEWING MULTIPLE PHOTOS

To switch to the thumbnail view press . The monitor will show four photos.

Press again and you'll have nine photos.

Press 🚳 a third time and you can see up to seventy-two photos!

Use the multi selector or the dials to move to different photos. Turn the command dial to move left or right across the thumbnails. Turn the sub-command dial and you'll move up or down through the thumbnails. Using one of the thumbnail views makes it easier to scroll through lots of photos to find the one you want.

The D90 offers still another view if you press 🚳 a fourth time. You're now in the calendar view. This view groups your photos by the day they were taken. If you took photos on a particular day there will be an image marking that day in the calendar. Use multi selector to highlight a day with a photo and you'll see a strip of thumbnails on the right.

To get over to the thumbnail strip press the button. Now one of the thumbnails is highlighted.

Use the multi selector to move up and down through the thumbnails. To see the selected thumbnail larger press and hold the button.

Press to switch back to the calendar. Now how do you get back to the regular thumbnail view? Press the button, but there's one important thing to know: you must have a calendar day highlighted, not one of images in the thumbnail strip. If you have a thumbnail highlighted press the button, then the button to get back to regular thumbnails.

SLIDE SHOWS

You can use your D90 to run a slide show of the photos on your memory card. The slide show feature is an easy way to show your photos to others and

not have to manually going through all the images. The slide show is accessed through the menu. Press the w button. The slide show settings are located in the Playback Menu. Use the multi selector to navigate to Slide Show.

There are a couple options in the slide show menu:

- 1. Start: Press to begin the slide show immediately.
- 2. Frame Interval: The frame interval is the amount of time each photo is shown before going to the next one.

While the slide show is playing you can pause it by pressing . When you pause the slide show you have the following options: Restart, Exit (takes you back to the menus), or change the frame interval.

There are a few more options available during the slide show:

- Skip forward or back: Using the multi selector press right to go forward and left to go back.
- Change the shooting information screen shown (details, histogram, highlights, etc.): Press up or down on the multi selector.
- Exit the slide show: Press any of the following buttons:
 - Displays shooting information

 - Returns to the Playback Menu
 - @: Press halfway down to switch to shooting mode. The monitor goes dark and you're ready to take a picture.

VIEWING PHOTOS ON TV

Standard Definition Devices: You can connect your D90 to a television or VCR using the supplied EG-D2 video cable. First choose the correct video mode in the Setup Menu. Press the w button then use the multi selector to navigate to Video Mode.

- 1. Choose the correct video mode. NTSC is used when connecting the D90 to an NTSC television or VCR. Use PAL if you're connecting to a PAL video device.
- 2. Turn off the camera.
- 3. Connect the video cable. The video connection on the D90 is under the door on the left side of the camera. Plug the cable into the bottom left opening.

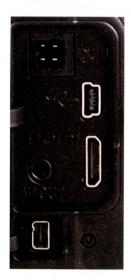

- 4. Set the television to the video channel.
- 5. Turn on the camera and press the button to start playing your photos. During playback the images will appear on the television or be recorded on video tape. The monitor on the D90 won't turn on.
- 6. Turn the camera off to stop playback.

High Definition Devices: You can connect your D90 to an HDMI device using a type C mini-pin HDMI cable. An HDMI cable is not included with the camera and must be purchased separately. By default the HDMI menu setting is on Auto. This means the camera will automatically choose the correct HDMI format for the device it's attached to. You can also choose the HDMI format yourself by choosing the HDMI mode in the Setup Menu. Press the @ button then use the multi selector to navigate to HDMI.

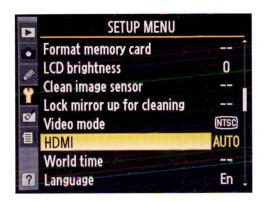

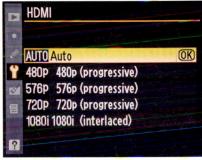

- 1. Choose the correct HDMI mode (or leave it set to Auto and go to Step 2).
- 2. Turn off the camera.
- 3. Connect the HDMI cable. The HDMI connection on the D90 is under the door on the left side of the camera. Plug the cable into the bottom right opening.

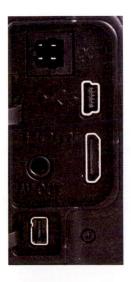

80 The Camera

- 4. Set the device to the HDMI channel.
- 5. Turn on the camera and press the button to start playing your photos. During playback the images will appear on the screen of the HDMI device. The monitor on the D90 won't turn on.
- 6. Turn the camera off to stop playback.

Section C: Menus

Pressing the Menu button brings up the main Menu screen on the monitor. There are six menu groupings, each represented by an icon down the left side of the monitor: Playback, Shooting, Custom Setting, Setup, Retouch and My Menu.

NAVIGATING THE MENUS

To navigate to the different menu groups press the multi selector left. Now one of the icons for the menu groups will be outlined in yellow.

Press the multi selector up and down to move between menu groups. To move over to the options for any group press the multi selector right. Now you are in the options section for a particular group. Press the multi selector up and down to highlight a setting. Then press the OK button to see the options for that setting.

TIP

If you are changing one of the settings and decide you really don't want to change to that setting, you can always press the Menu button to immediately return to main menu list (no change will be made to the setting you were just in).

TIP

Some of the settings in the menus can also be changed through the control panel on top of the camera or the Shooting Info Display (press to bring it up). When possible I think it's more convenient to use the control panel or Shooting Info Display because they're easy to access and you don't have to look through menus to find the settings. I've noted in the information for each menu item whether you can access the setting through the control panel or Shooting Info Display.

PLAYBACK MENU

The Playback Menu adjusts settings related to when you are viewing your photos.

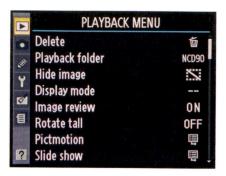

DELETE

In Part 1B Viewing/Reviewing Images you learned how to delete photos in the playback mode using the button. You can also delete photos through the Playback Menu. Using the Playback Menu is a faster way when you want to delete a lot of photos at once.

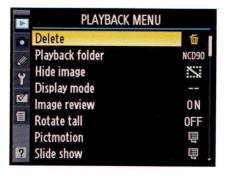

You can choose to delete specific photos, photos from a particular date, or all your photos at once.

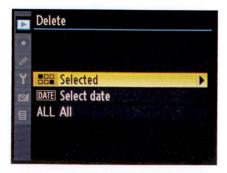

If you choose to delete photos by date, you'll see a list of the dates the photos on your memory card were taken.

If you choose to delete selected photos, you'll see thumbnails of your images. Use the left and right of the multi selector to navigate through the thumbnails. To make one of the thumbnails larger press and hold the Zoom button. When you release the Zoom button you're back to the thumbnail view.

When the yellow box is surrounding a photo you want to delete, press up or down on the multi selector. A trash can icon will appear in the top right corner of the thumbnail. This image is now marked to be deleted.

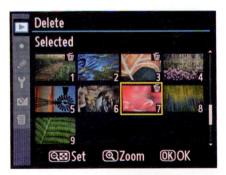

If you change your mind, simply press up or down again and the trash can will be removed.

Once you've marked all the photos you want to delete press the OK button. The camera will confirm you want to delete the photos whether or not you selected photos or all photos.

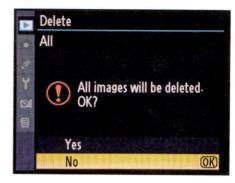

If you decide you don't want to delete any photos, press the Menu button. Even if you had thumbnails marked with the trash can, nothing will be deleted.

PLAYBACK FOLDER

The camera stores your photos in folders on the memory card.

By default there is a single folder named NCD90.

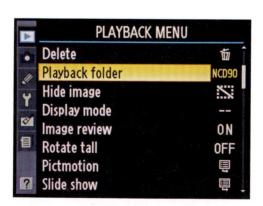

This setting designates which folder of images you'll see when you playback your photos. You have the choice to play back images from the current folder or all folders. If you used this memory card in another Nikon camera (and the photos are still on the card), there will be another folder created by that camera on the card. If you choose "All" you will likely be able to playback those photos on the D90.

HIDE IMAGE

Images you designate as "hidden" will not be shown in playback and cannot be deleted. Once labeled as hidden you have to go to the Hide Image setting to see the hidden images or to "unhide" them.

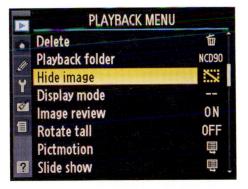

The Hide Image option gives you the same choices as the Delete option above: selecting individual images, selecting by date and choosing all photos.

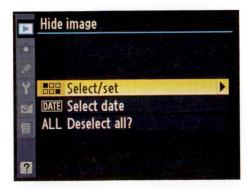

If you choose to hide selected photos, you'll see thumbnails of your images. Use the left/right and up/down on the multi selector to navigate

through the thumbnails. To make one of the thumbnails larger press and hold the Zoom button. When you release the Zoom button you're back to the thumbnail view.

When the yellow box is surrounding a photo you want to hide (or unhide) press the button. Images marked to be hidden will have a rectangle with a dashed outline in the corner.

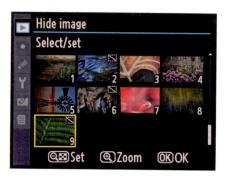

If you hide images you can always come back later and reveal the images.

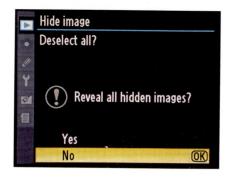

DISPLAY MODE

Display Mode controls how much information is available about your photos in the playback mode.

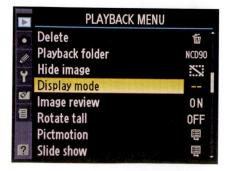

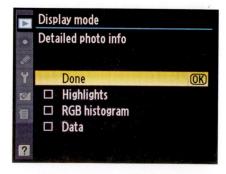

- Highlights shows the highlight warning screen.
- RGB Histogram shows histograms for the red, green and blue channels of a photo.
- Data shows three screens of information about what settings were used for each photo.

See Part 1B Viewing/Reviewing Images for more information. To display the Highlights, RGB Histogram and Data screens the boxes next to them need to be checked. Use the multi selector to move up and down the list, press the OK button as you highlight each item in the list. This will add the check mark. Most important, once you check all the boxes you need to go back up to "Done" and press the OK button to save the changes.

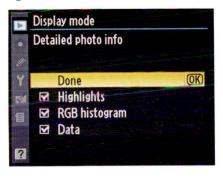

IMAGE REVIEW

Image review controls whether your picture appears on the monitor right after you take it.

On: Photo appears on the monitor after you take a picture.

Off: No photo appears, the monitor shows the shooting info display.

Image review makes it easy to see what you just shot. If you don't want to look at every photo right after you take it, you may want to turn it off.

ROTATE TALL

Rotate Tall controls whether vertical photos (portrait orientation) are rotated during playback. "On" means vertical photos will be shown correctly during playback. "Off" means vertical photos will be shown sideways and you have to turn the camera (or your head) to view them. There's a trade-off. With the "Off" setting your vertical photos will be larger on the monitor, but you have to turn the camera. With the "On" setting you won't have to turn the camera, but your vertical photos will be smaller.

PICTMOTION

Pictmotion is an enhanced slide show.

You can select which images on your memory card are part of the Pictmotion show. When the yellow box is surrounding a photo you want to include press the button. Images selected will have a check mark in the corner.

You also have options for the type of music you want to play during the show and how the photos transition.

SLIDE SHOW

A quick way to share the photos on your memory card is to run a slide show. It's a lot easier than repeatedly pressing the multi selector in playback mode if you want to show a lot of pictures.

Frame interval allows you to choose how long each photo will be displayed.

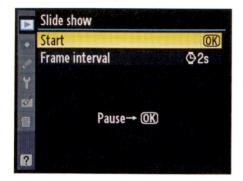

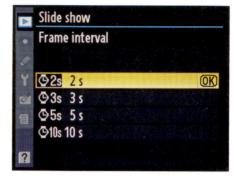

There are a number of options available while the slide show is playing:

- Skip back/skip ahead
 - Left on the multi selector goes to the previous photo.
 - Right on the multi selector skips to the next photo.
- Display shooting information
 - Press up or down on the multi selector to display different screens of information about the photo.
- Pause slide show
 - Press OK button. Options appear to restart the slide show, change the frame interval, or exit the slide show.
- Return to Playback Menu
 - Press Menu button. The slide show ends and you're taken back to the Playback Menu (same menu where you started the slide show).
- Go to Playback Mode
 - Press Play button. Exits slide show and changes to Playback Mode.
 If you were in the thumbnail view before the slide show, the
 thumbnails will return. If you were in the full-frame view, nothing will appear to change, but you're in Playback Mode. Use the
 multi selector to move through the photos or view the shooting
 information.
- Go to Shooting Mode
 - Press shutter-release button halfway to exit the slide show and switch to Shooting Mode.

PRINT SET (DPOF)

Print Set allows you to select photos that you want to print directly from the camera.

Choose "Select/set" and you'll see thumbnails of the photos on your memory card.

Use the left and right of the multi selector to navigate through the thumbnails. To see one of the thumbnails in full-frame view press and hold the Zoom button. When you release the Zoom button you're back to the thumbnail view. When the yellow box surrounds a photo you want to print, press up on the multi selector. A printer icon and "01" will appear in the top right corner of the thumbnail. The number indicates how many copies of the photo will be printed.

Press the up multi selector to increase the number of photos to be printed. Press the down multi selector if you don't want to print that photo. After making your selections press the OK button. You now have the option to have information printed on the photo. Data imprint is shooting information (aperture, shutter speed) and imprint date is the date the photo was taken.

At any time you decide you don't want to print a photo, press .

After making any selection here, press OK and your print order will be saved. When you're ready to print take the following steps:

- 1. Turn the printer on.
- 2. Turn the D90 off.
- 3. Connect the D90 to the printer using the USB cable that came with the camera.
- 4. Turn the camera on.
- 5. The PictBridge screen will appear and you'll see a photo from your

memory card. Press the button and choose "Print (DPOF)" to print the set of photos you've already selected. You can also choose "Print select" to choose different photos to print. The index print option will print small thumbnails of your pictures with many photos per page. It will also print all of the JPEG photos on your memory card (up to 256).

SHOOTING MENU

The Shooting Menu lists settings that are used when you take a picture.

SET PICTURE CONTROL

The Set Picture Control options give you the ability to fine tune how the colors, contrast, and sharpness of your subject are captured by the camera.

If you're happy with the color, contrast, and saturation in your pictures then you can leave Set Picture Control on the Standard setting. It's only if you're unsatisfied with the results that you'd want to consider one of the other settings. Keep in mind that if you change the setting, it will affect every photo you take. The Vivid setting might make your landscapes more vibrant, but people pictures won't look so great.

Standard: Works well for most photography.

Neutral: Very little processing in camera. Offers the most flexibility for extensive processing or retouching later.

Vivid: Increases saturation, contrast, and sharpness. Particularly emphasizes reds, greens, and blues. Best used for nature photography.

Monochrome: Images are all taken in black and white.

Portrait: Portrait reduces contrast and softens skins tones.

Landscape: Specifically for photographing landscapes and city scenes.

If you press the right side of the multi selector with any of the above options selected you'll have the opportunity to fine tune the settings for sharpening, brightness, saturation and hue. After making any changes press OK to save the changes.

- Quick Adjust: Automatically increases or decreases the strength of all the settings below.
- Sharpening: Makes images appear sharper by adding more definition between light and dark areas.
- Contrast: Adjusts amount of contrast (not available if Active D-Lighting is on)
- Brightness: Makes pictures brighter or darker (not available if Active D-Lighting is on)
- Saturation: Controls the intensity of the colors.
- Hue Adjustment: Affects the appearance of colors overall, introducing slight shifts in color. Negative numbers shift blues toward green, green toward yellow and reds toward purple. Positive numbers shift reds toward orange, greens toward blue and blues toward purple.

If you press the button, this grid will appear which shows how much contrast and saturation the different settings have in relation to each other.

MANAGE PICTURE CONTROL

Manage Picture Control lets you save settings from the Set Picture Control adjustments described above. This gives you the ability to fully customize these settings and save them as separate files. Once they are saved you could load them onto another camera, thereby saving you from having to enter all the settings again.

IMAGE QUALITY

Image Quality lets you choose if you want to shoot a JPEG file, a RAW file or a RAW plus a JPEG file. You can also select the quality level of the JPEG.

Fine is the highest JPEG quality setting. The RAW + JPEG options will record a RAW and JPEG file for each photo taken. These choices can also be made

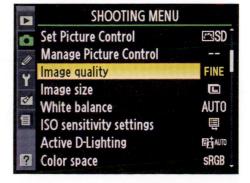

through the control panel or Shooting Information Display. For more information on quality settings and JPEG and RAW files see Part I: Section A.

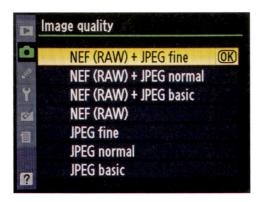

IMAGE SIZE

The Image Size menu is available if you choose one of the JPEG options for Image Quality. If you choose the RAW file format Image Size will be graved out because there is just one size for the RAW file.

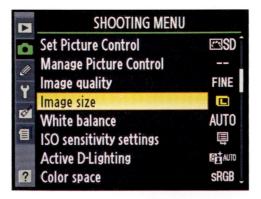

The options show you the pixel dimensions of each size and the corresponding number of megapixels (MP). Choosing the largest quality size will give you the most options for future use of our photos. These choices can also be made through the control panel or Shooting Information Display. For more information on image size see Part I: Section A.

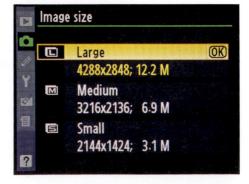

WHITE BALANCE

White balance helps to avoid unnatural color casts when photographing under various light sources.

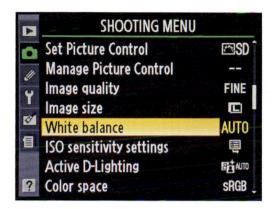

Auto white balance is a good option that doesn't require you to change the white balance every time you're under a different light source. White balance can also be set through the control panel or Shooting Information Display. For more information about the white balance settings see Part I: Section A.

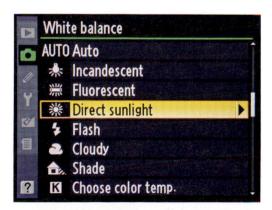

Setting the white balance in the menu gives you the option to use a color grid to fine-tune the white balance setting for auto, incandescent, direct sunlight, flash, cloudy and shade. If the white balance is doing a pretty good job, but you'd like to slightly adjust how warm or cool the photos are, try this out. Select the white balance you want to fine-tune and press the multi selector right to bring up the grid. Then use the multi selector to move the black dot around. For more warmth try the yellow or red quadrants. To shift cooler try the green or blue quadrants. Press OK when you're done. Press to cancel.

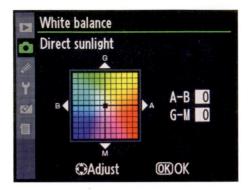

Fluorescent fine-tuning doesn't have a color grid, but it lets you choose different types of fluorescent light. If you're not sure which one is right, pick one, take a picture, and see how the image looks. Repeat the process until you find the one that gives you the best results.

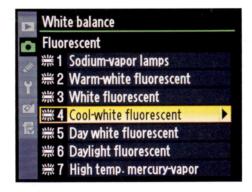

The Choose Color Temperature provides you with a list of color temperatures to select from. This is a good choice if you need to be very precise with the color temperature you're using.

V	Vhite balance	
0	hoose color temp.	
11	5000 K)
ú	5260 K	
1	5560 K	
01	5880 K	
尼	6250 K	0.280.2%
	6670 K	4-27
	7140 K	Marie Control

If neither Auto white balance nor any of the available choices are producing good results, you may want to try setting a custom white balance. It's the last choice in the white balance menu: Preset Manual.

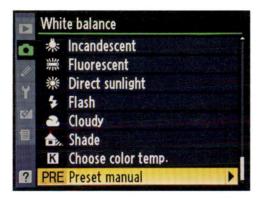

The D90 can store up to five custom white balance settings. If you have multiple custom white balances it's a good idea to label them so you know which is which (select the preset then press the button).

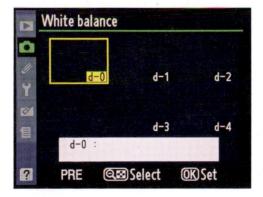

How to Record a Custom White Balance:

- 1. Set White Balance to PRE.
- 2. Press and hold the button until "Pre" starts flashing in the control panel.
- 3. Take a picture of a white or neutral gray object (a piece of paper works great) under the same lighting where you want to photograph. Get close or zoom in on the object so that it completely fills the viewfinder. The object doesn't have to be in focus.
- 4. If the camera was able to measure the light the message "Good" will appear in the control panel. If there was an error the control panel will flash "no Gd".
- 5. If you receive the "no Gd" message or "Pre" stops flashing before you can take photo, just start back at #2 in this list.

ISO SENSITIVITY SETTINGS

The ISO Sensitivity refers to how sensitive the sensor is to light. At higher ISO numbers the camera needs less light to make a good exposure. This can allow you to use faster shutter speeds or smaller apertures while still achieving a proper exposure. Be aware that using high ISOs can also produce noise, which causes a grainy appearance that results in a loss of fine detail. ISO Sensitivity can also be set through the control panel or Shooting Information Display. For more information about the ISO sensitivity see Part I: Section A.

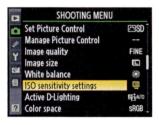

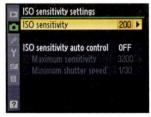

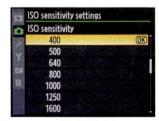

The ISO Sensitivity Settings is also where you can turn on Auto ISO. This feature lets the camera change the ISO, so you don't have to worry about changing the ISO when you go from bright lighting to dim light. This menu option is the only place to turn on/off Auto ISO.

Auto ISO lets you set the Maximum Sensitivity and Minimum Shutter Speed. You can use

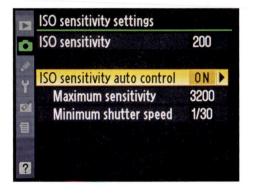

these settings to avoid a very high ISO and to make sure the camera doesn't pick a shutter speed that is too slow. For more information about Auto ISO see Part I: Section A.

	ISO sensitivity settings	
۵	Maximum sensitivity	
2	400	
T	800	
0	1600	
目	3200	OK
	Hi 1	
?		

ACTIVE D-LIGHTING

Active D-Lighting is an adjustment the camera applies to retain more detail in the highlight and shadow areas of your pictures. It can be useful in high-contrast situations where part of the scene is very bright and part is dark; for example, photographing outside with your subject in the shade, but other parts of the scene are brightly sunlit. The Auto setting will vary the level of Active D-Lighting depending on the photograph. If you pick one of the other settings the same amount of Active D-Lighting will always be applied.

COLOR SPACE

The two color space options are sRGB and Adobe RGB. Adobe RGB captures a wider range (gamut) of colors than sRGB. If you plan to retouch or enhance your photos on the computer

Adobe RGB is a better choice. If you're not going to modify your photos, but just print or display them as is then I'd recommend sRGB.

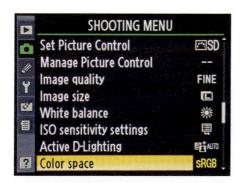

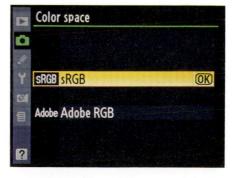

NOISE REDUCTION

Noise can have negative effects on your images, but using noise reduction can help. Noise can produce a mottled appearance in areas with a

solid color (such as a blue sky), soften fine details, and cause random pixels (appearing as pinpoints in your photo) to be brightly colored. Noise is caused by taking pictures at high ISOs and by using very long exposures (multiple seconds). The D90 offers two types of noise reduction: Long Exposure Noise Reduction and High ISO Noise Reduction.

LONG EXPOSURE NOISE REDUCTION

Long Exposure Noise Reduction will only be in effect when the shutter speed is over eight seconds. When noise reduction for long exposures is applied there is a delay before the photo is recorded on the memory card. For instance, if an exposure was ten seconds long there would be a five to ten second delay before the photo was recorded. Much longer than for a regular photo. This should not be a concern, but simply something to be aware of if you notice it's taking longer to record the photo. You can't take another photo until the current one has been recorded. I would recommend leaving this setting "On".

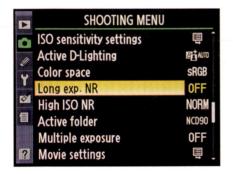

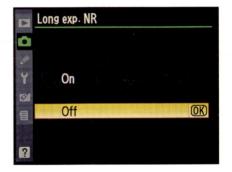

HIGH ISO NOISE REDUCTION

High ISO Noise Reduction will only be in effect when the ISO is set to 800 or higher. Using noise reduction slows down how fast the camera can record photos. Therefore, if you use the continuous shooting mode (with noise reduction on) you won't be able to take pictures as quickly. Keep this in mind if you're trying to capture action shots, as you might want to turn noise reduction off.

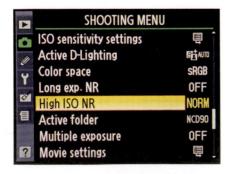

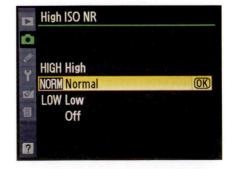

ACTIVE FOLDER

The Active Folder setting lets you choose which folder you want your photos recorded in. By default there is just one folder into which the images are recorded. Using this setting you can create additional folders, rename folders and choose between folders you've already created.

MULTIPLE EXPOSURE

The Multiple Exposure option allows you to take up to three photographs and have the camera automatically blend them together so that the three images are recorded as one photo. You'll want to have the Auto Gain "On" for this effect. Multiple exposures can be used to create impressionistic images and other special effect imagery.

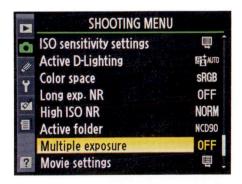

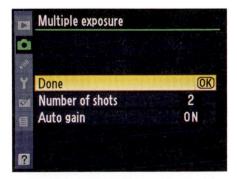

MOVIE SETTINGS

The Movie Scttings are options for using the D90's video mode. You can choose from three quality settings, as well as whether you want sound to be recorded. For more information about these settings and the video function see the end of Part I: Section A.

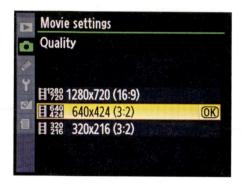

CUSTOM SETTING MENU

The Custom Setting Menu offers options for specializing camera functions and features to your needs/preferences. You won't need to use this menu very much if you don't want to. Some settings you can set once and won't need to change them. The custom settings are divided into six groups: Autofocus, Metering/exposure, Timers/AE lock, Shooting/display, Bracketing/flash, and Controls.

RESET CUSTOM SETTINGS

If you reset the custom settings menu all the settings are returned to their defaults (what they were when you got the camera).

AUTOFOCUS

AF-AREA MODE

The options for autofocus area mode control how the autofocus system locks onto a subject. Single Point stays focused on the same area in the viewfinder. Dynamic Area is good for tracking moving subjects. Auto-area lets the camera decide what to focus on, often the nearest subject in front of the camera. 3D-tracking is useful when photographing subjects that aren't going to move very much. For more information about AF-area modes see Part I: Section A.

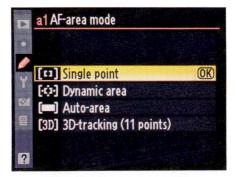

CENTER FOCUS POINT

Center focus point gives you the choice between a normal or wide zone for the center focus box in the viewfinder. The normal zone is a good choice for subjects in the middle of the viewfinder that aren't moving. The wide zone is suited for moving subjects that are in the center of the viewfinder. The only change you'll notice is when the center focus box is selected. For "normal" it has a rectangular outline surrounding it.

When using "wide" the rectangle stretches out and looks like two brackets. This is increasing the size of the focus point. If you subject is moving but stays within the "brackets" it will stay in focus.

BUILT-IN AF-ASSIST ILLUMINATOR

The autofocus assist uses the lamp on the front of the D90. It looks like a little headlight near the shutter release button. If you have AF-Assist set to "On" the lamp will light up when the camera senses dim lighting to literally throw some light on your subject. By shining a mini-spotlight on your subject the camera creates more contrast, making it easier for the autofocus to lock on to your subject.

AF POINT ILLUMINATION

AF point illumination controls whether the focus boxes in the viewfinder light up in red when you press the shutter release button halfway.

 Auto: The D90 will only do this when there is dim lighting or the subject is dark.

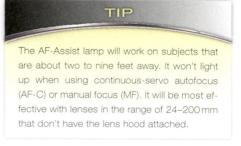

- On: The boxes will always light up red.
- Off: The boxes will never light up.

I recommend using Auto or On. It's certainly useful when the lighting is poor, but you may find it convenient to have the boxes light up all the time.

FOCUS POINT WRAP-AROUND

Focus point wrap-around affects how the focus boxes in the view-finder are selected using the multi selector. Let's say you select the far left box. What happens if you continue to press the multi selector to the left? How about if you select the top focus box ... what happens if you press up on the multi selector? That's where Wrap and No Wrap come in. If you choose Wrap the selected box will move to the opposite end of the line of boxes. Let's take the two examples I described. The left box is selected, you press left again, now the far right box is selected. The top box is selected, you press up again, now the bottom box is selected. If you choose No Wrap you can continue to press left or up in the examples I gave, but the selected box won't move. It'll be like it hit a wall and can't go any further.

AE-L/AF-L FOR MB-D80

The MB-D80 is the vertical grip attachment for the D90. On the grip is another AE-L/AF-L button. These are the options for the function of that button.

- AE/AF Lock: Press and hold to lock the exposure and focus.
- AE Lock Only: Press and hold to just lock the exposure.
- AF Lock Only: Press and hold to only lock the focus.
- AE Lock (Hold): Press and release to lock the exposure, press again to remove the exposure lock. It's convenient because you don't have to hold down the button. The exposure lock will go away if the meter in the viewfinder goes dark or the camera is turned off.
- AF-On: If this option is selected then you have to press the AE-L/AF-L button to use autofocus. The shutter release button will no longer activate autofocus.
- FV Lock: Press and release to lock the flash value (how much power the flash is going to put out). Press again to remove the flash value lock. This will work for the built-in flash as well as the SB-900, SB-800, SB-600, SB-400 and SB-R200.
- Focus Point Selection: Press and hold the AE-L/AF-L button then turn the sub-command dial (on the vertical grip) to change which focus box is selected.

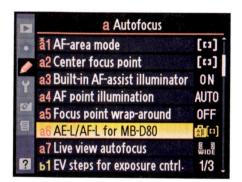

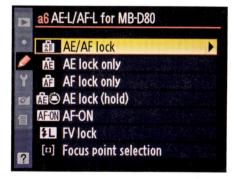

LIVE VIEW AUTOFOCUS

This option sets the focusing mode for live view. See the end of Part 1A for more information about the live view function.

- Face Priority: The camera detects faces in order to focus on the people in your photo.
- Wide Area: There is a focus box that you can move around to control where the camera focuses. Use the multi selector to position the box.
- Normal Area: Same as wide area, but the focus box is much smaller, for more precise placement of focus. Use the multi selector to move the box around.

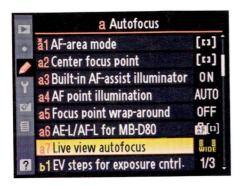

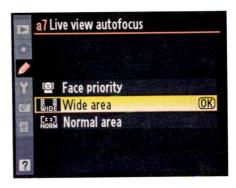

METERING/EXPOSURE

EV STEPS FOR EXPSOURE CONTROL

EV Steps control the increments for changes to shutter speed, aperture and auto bracketing. I recommend 1/3 step as it offers the most precise adjustments. Here are a couple examples:

- 1/3 step increments for changing the aperture from f/8 to f/11: f/8, f/9, f/10, f/11
- 1/3 step increments for changing the shutter speed from 1/125 to 1/250: 1/125, 1/160, 1/200, 1/250.

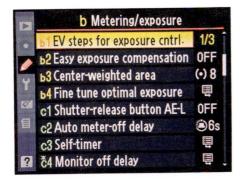

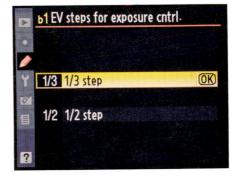

EASY EXPOSURE COMPENSATION

Easy exposure compensation offers a quick way to change exposure compensation. With regular exposure compensation you have to press the exposure compensation button while turning the command dial. Easy exposure compensation lets you change the compensation without pressing the button. Here's how it works: when using Program, Aperture Priority or Shutter Priority modes you're not using both the command and sub-command dials. The dial that you're not using would then change exposure compensation. You turn the dial and

you're automatically changing the compensation. This is very convenient but there are a couple things to be aware of: 1) You don't see any numbers changing just the +/- symbol appears to let you know you've changed the compensation, 2) You could accidentally turn the dial and engage exposure compensation without knowing it.

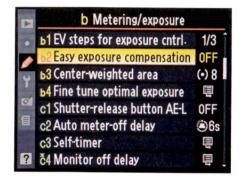

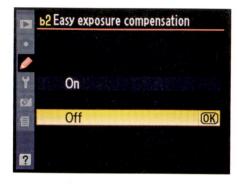

CENTER-WEIGHTED AREA

As discussed is Part 1A, center-weighted metering emphasizes the center of the viewfinder when calculating the exposure. This option lets you choose the size of the center area given the most weight.

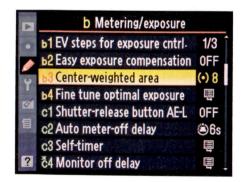

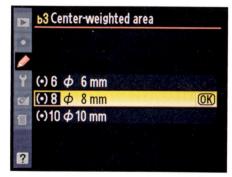

FINE TUNE OPTIMAL EXPOSURE

This option enables you to fine-tune how exposure is calculated by the three metering methods. This is similar to using exposure compensation but there is no reminder (such as the +/- icon) that you've made any compensation. This option is not for correcting exposure from picture to picture, you'll still want to use exposure compensation for that. These adjustments should be used if you're not satisfied with the metering results in all circumstances because these changes will be affecting every photo equally.

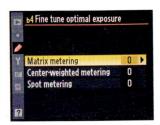

TIMERS/AE LOCK

SHUTTER-RELEASE BUTTON AE-L

By default the shutter release button locks focus when pressed half-way. Shutter-release button AE-L controls whether the shutter release button locks the exposure when it's pressed halfway down.

Off: Shutter release button does not lock the exposure (default setting, and good for most types of photographs).

On: The exposure is locked when the shutter release button is pressed halfway down.

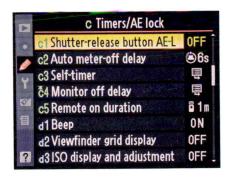

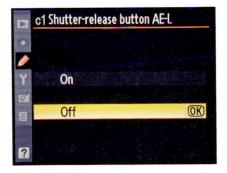

AUTO METER-OFF DELAY

Sets the amount of time the aperture and shutter speed are displayed in the control panel and viewfinder. After the delay the meter "goes to sleep" and the aperture and shutter speed disappear. You can bring them back with a half press of the shutter release button.

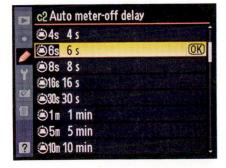

SELF-TIMER

With the self-timer you can set the length of the delay before the picture is taken. To actually use the self-timer you need to choose the self-timer release mode (use the control panel to set it, see Part 1A). You can also select the number of photos that will be taken. The number of photos selected are taken in a burst. For example, let's say you choose a ten second delay and three photos. The camera will delay for ten seconds then take three photos in a row. It does not delay ten seconds in between each photo.

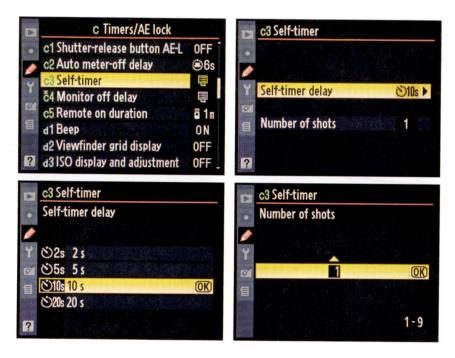

MONITOR OFF DELAY

Monitor Off Delay controls how long information or photos are displayed on the monitor. If you don't press any buttons for a certain period the monitor will go dark. You can choose separate delays for playback, menus, shooting info display and image review (when the photo appears after you take it). Each choice has the same selection of delay times: 4, 10 or 20 seconds and 1, 5 or 10 minutes.

REMOTE ON DURATION

Remote on Duration is related to using the optional remote control to take a picture. Once you select Delayed Remote or Quick Response Remote, the "remote on duration" is the amount of time the camera will wait for you to use the remote. If you don't use the remote in that period of time the D90 will switch back to your previous release mode (single or continuous). To choose the release mode use the control panel, for more information see Part 1A.

SHOOTING/DISPLAY

BEEP

The D90 automatically beeps whenever the autofocus locks onto a subject or when the self-timer or remote control is used. If you don't like the beep you can turn it off.

VIEWFINDER GRID DISPLAY

Turns on a grid in the viewfinder. The grid is useful to help you keep vertical and horizontal lines (horizons, buildings, trees) straight in your compositions.

ISO DISPLAY AND ADJUSTMENT

By default the ISO is not displayed in the control panel, but this setting gives you a way to change this. If you choose "Show ISO sensitivity" the ISO will be displayed in place of the frame-count number (bottom right of control panel). In addition, if you choose "Show ISO/Easy ISO" you'll also be able to change the ISO just by turning the command dial.

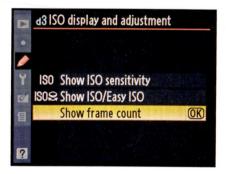

VIEWFINDER WARNING DISPLAY

Turn viewfinder warnings on or off. Viewfinder warnings include symbols telling you the low battery is low or that no memory card is inserted.

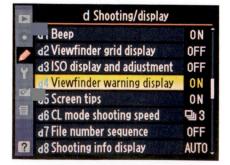

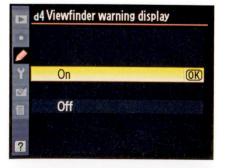

SCREEN TIPS

When you press the Info button twice you access the setting across the bottom of the Shooting Display Information screen. By default the name of the selected setting is displayed, if you don't want the setting name displayed set Screen Tips to off.

CL SHOOTING MODE

The D90 offers a low and a high continuous shooting mode. The high mode (4.5) is the greatest number of photos the camera can take in one second. Here you can choose what you want the low continuous setting to be. By using the low mode you can still take pictures continuously, just at a slower rate.

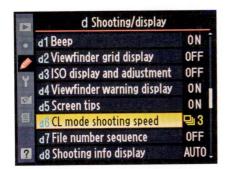

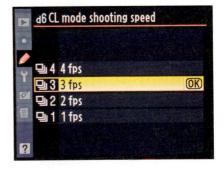

FILE NUMBER SEQUENCE

File Number Sequence controls how the D90 numbers your photos.

On: The camera continually counts up when numbering (0001, 0002, 0003, 0004, etc.) all the way to 9999, then it returns to 0001. This sequence will continue even if a new memory card is used or the memory card is formatted.

Off: Every time you put in a new memory card, reformat a memory card or create a new folder the camera resets the file numbering back to 0001.

Reset: Reset the file numbering to the highest number in the current folder.

I recommend setting it to "On" because otherwise you run the risk of having two photos with the same file name on your computer. This could lead to one of the photos being accidentally overwritten or deleted.

SHOOTING INFO DISPLAY

The Shooting Info Display is what appears when you press the Info button on the back of the camera. There are two appearance options for the text and background. You can have light text on a dark background or dark text on a light background.

The Auto option will switch between these two views as it senses changes in the amount of light around the camera. If you want it stay one way or the other (no matter the lighting) choose Manual and select the appearance you want.

LCD ILLUMINATION

If you set LCD Illumination to "On", every time you press the shutter release button halfway the control panel will light up. Otherwise to turn on LCD illumination you turn the ON/OFF switch past ON to the light bulb symbol.

EXPOSURE DELAY MODE

Exposure Delay Mode causes a delay of about one second after you press the shutter release button before the exposure begins. Every time a photo is taken the mirror is raised and this creates small vibrations which can reduce image sharpness. The purpose of this delay is to avoid the vibrations created when the mirror is raised. The vibrations have the most noticeable effect with telephoto lenses and between shutter speeds of 1/4 and 1/30 of a second. While this setting does offer some benefits, it may not be practical to have a one second delay for every photo you take. Especially if you are trying to capture a fleeting moment.

FLASH WARNING

In the exposure modes P, S, A and M the flash will not fire unless you have it raised up. However, with the Flash Warning set to "On" the flash symbol (lightning bolt) will flash in the viewfinder to warn you that the camera thinks the flash should be used (poorly lit subject, dim lighting).

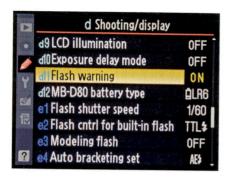

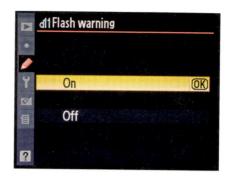

MB-D80 BATTERY TYPE

This setting applies only if you have the MB-D80 vertical grip and you're **not** using the standard rechargeable batteries. If you are using AA batteries to power the vertical grip you need to tell the D90 what kind of AA's they are so it can accurately display how much power is left.

BRACKETING/FLASH

FLASH SHUTTER SPEED

Here you can set the slowest shutter speed the camera will choose when the flash is being used. If you're handholding your camera while using the flash, try a setting of 1/30 or 1/60. That way the shutter speed won't be too slow for you to hold the camera still.

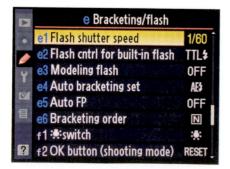

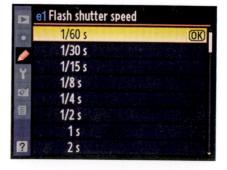

FLASH CONTROL FOR BUILT-IN FLASH

There are three flash modes to choose from, plus the Commander mode which allows you to control other Nikon flashes wirelessly from you D90.

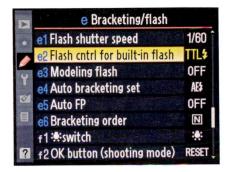

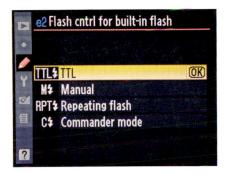

TTL: Good all-around flash mode, camera decides how much power the flash should put out.

Manual: You choose the exact amount power of the flash.

Repeating Flash: Flash fires off multiple times during one exposure, produces strobe-like effect.

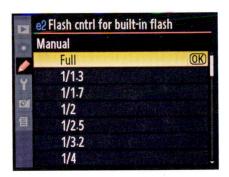

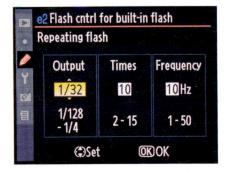

TTL is going to be fine in most cases. If you want to tweak the flash's exact power output go to Manual. Since the Repeating Flash has a special effect/particular application it won't be used as often.

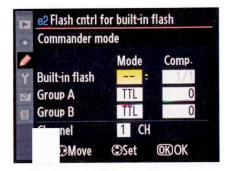

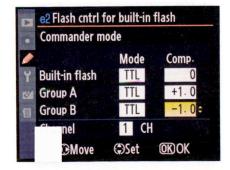

The Commander mode turns the built-in flash into a powerful device that can control numerous other Nikon flash units wirelessly. It can control the following flashes: SB-900, SB-800, SB-600 and SB-R200. The first column of boxes is the mode of the flash units. The second column is the power of the flash. You can choose the mode of the built-in flash or turn it off by setting it to "–". Even if the built-in flash is "off" it can still control other flash units. Use left and right on the multi selector to move from one box to the next. Use up and down on the multi selector to change the setting or value for that box. For your other flash units to be controlled by the D90 they must be set to their "remote" mode. Check your flash manual to find out how to do this.

MODELING FLASH

The Modeling Flash makes it very easy to be sure a group of wireless flashes are all working properly. Set it to "On", then press your depth of field preview button. All the flashes should fire if they are communicating with the D90. This test firing of the flashes also allows you to see how the flashes will light the subject.

AUTO BRACKETING SET

The Auto Bracket Set determines what settings are adjusted when you take a series of bracketed photos.

AE & Flash: Camera will adjust the exposure (aperture and/or shutter speed) as well as the power of the flash (if used).

AE Only: Only the exposure (aperture and/or shutter speed) is changed.

Flash Only: Only the power of the flash is adjusted.

WB Bracketing: Only one photo needs to be taken and the D90 automatically creates multiple photos with bracketed white balance values.

ADL Bracketing: Camera brackets the amount of Active D-Lighting it applies to each photo.

AUTO FP

Tuning "On" Auto FP enables FP high-speed sync and allows you to use shutter speeds faster than 1/200 with an external flash unit. Auto FP does not work with the built-in flash. Therefore, when using the built-in flash the fastest shutter speed you can use is 1/200.

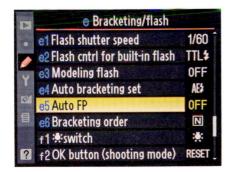

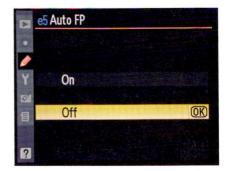

BRACKETING ORDER

This setting determines the order in which auto bracketed photos are taken. This does not affect anything about the photos themselves, just the order they're captured.

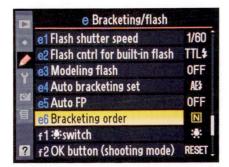

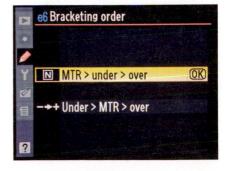

CONTROLS

ILLUMINATION SWITCH

By default if you turn the ON/OFF switch past "ON" the control panel lights up. You can also choose to have the Shooting Info Display appear when you illuminate the control panel (choose "Both"). To turn the illumination off simply turn the ON/OFF switch to the lightbulb past ON again.

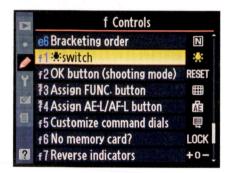

OK BUTTON (SHOOTING MODE)

This setting only affects the function of the OK button in the shooting mode.

Reset: Pressing the OK button will automatically select the center focus box in the viewfinder (moving it from whichever box was selected previously).

Highlight: A press of the OK button will illuminate whichever focus box you have selected (it will not change your selection)

Not used: OK button does nothing in the shooting mode.

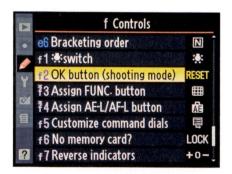

ASSIGN FUNCTION BUTTON

Think of the function button as a shortcut button. The function button is located on the front of the D90 near the Autofocus Assist Light. It has "Fn" printed next to it.

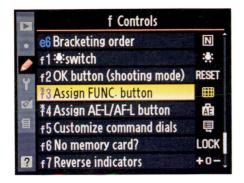

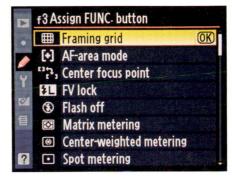

You can access one of the following functions with this button:

- Framing grid: Press and hold the Function button, then turn the command dial to turn the framing grid on or off.
- AF-area mode: Press and hold the Function button, then turn the command dial to chose an AF-area mode.
- Center focus point: Press and hold the Function button, then turn the command dial to switch between the two center focus point options.
- FV lock: Press the Function button to lock the flash value. Press it again to release the lock.
- Flash off: Flash is turned off as long as the Function button is held down.
- Matrix metering: Matrix metering is used as long as the Function button is held down.
- Center-weighted metering: Center-weighted metering is used as long as the Function button is held down.
- Spot metering: Spot metering is used as long as the Function button is held down.
- Access top item in MY MENU: Press the Function button and the options will be displayed for the top item in the MY MENU list.
- + NEF (RAW): Press the Function button to have the D90 start recording RAW files for subsequent photos. It will continue to record RAW files until the Function button is pressed again.

Think about which of these functions you'll use the most and choose that one for the function button. Using the Function button and the command dial to change a setting is quicker than going into a menu.

ASSIGN AE-L/AF-L BUTTON

This menu item sets the function for the button. The default function locks the exposure (meter reading) and the focus when you press and hold it.

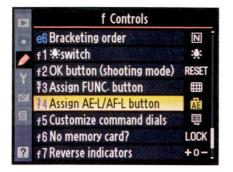

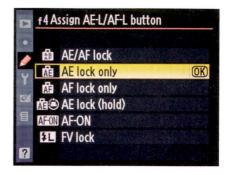

Here are all the options you can choose from:

- AE/AF Lock: Press and hold to lock the exposure and focus.
- AE Lock Only: Press and hold to just lock the exposure.
- AF Lock Only: Press and hold to only lock the focus.
- AE Lock Hold: Press and release to lock the exposure, press again to remove the exposure lock. It's convenient because you don't have to hold down the button. The exposure lock will go away if the meter in the viewfinder goes dark or the camera is turned off.
- AF-ON: If this option is selected then you have to press the AE-L/ AF-L button to use autofocus. The shutter release button will no longer activate autofocus.
- FV lock: Press and release to lock the flash value (how much power the flash is going to put out). Press again to remove the flash value lock. This will work for the built-in flash as well as the SB-900, SB-800, SB-600, SB-400 and SB-R200.

CUSTOMIZE COMMAND DIALS

You can customize what the command dials do and how they rotate.

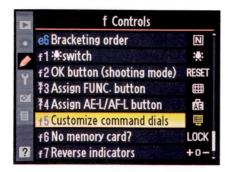

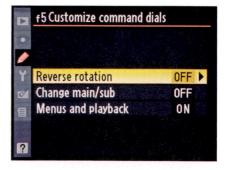

Reverse Rotation: Change the direction you need to rotate the dials to increase or decrease a number, or cycle through a group of settings. OFF = regular function, ON = reversed function.

Change Main/Sub: Switch what the main and sub-command dials control. OFF = regular function, ON = functions of dials are switched.

Menus and Playback: These settings control how the dials are used when navigating through the menus and your pictures.

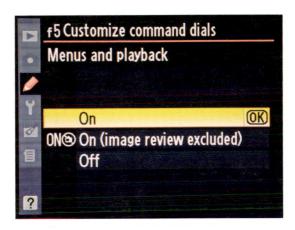

On: You can use the command dials to move through menus and during playback.

On (image review excluded): Command dials will not do anything during image review (when photo appears on the monitor after you take it).

Off: The command dials cannot be used at all during playback or in the menus. You must use the multi selector to navigate through menus and in playback.

NO MEMORY CARD?

The No Memory Card option lets you choose what the camera will do if there is no memory card in the camera and you try to take a picture.

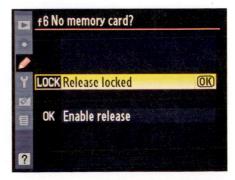

Release locked means you can't take a picture when there is no memory card. If you try and take a picture nothing will happen. Keeping the D90 set to Release Locked is a good safety precaution to avoid accidentally taking pictures when there's no memory card.

If you choose "Enable release" the camera will give you no warning that there is no memory card. It will let you meter and change setting just as if everything is normal. You can even take a picture. The picture will appear on the monitor, but it will have the word "Demo" in the top left. You can even go through all the screens of information (histogram, highlight warning, etc.) for the photo. This photo is in the camera's temporary storage, it's not really saved anywhere.

REVERSE INDICATORS

The indicators used for exposure and exposure compensation have a positive end and a negative end. This setting lets you choose whether you want the positive on the left and negative on the right, or vice versa.

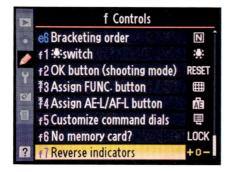

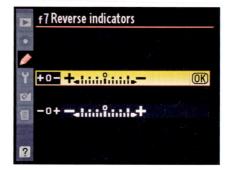

SETUP MENU

There are only a few settings in the Setup Menu that you'll likely need to come back to after you set them initially.

FORMAT MEMORY CARD

After you have downloaded your photos to your computer and backed them up (see Part 2), you can erase your memory card to make way for new photos. This is called formatting your card. After choosing "Format memory card" a warning message will appear to make sure you really want to delete all your photos. It's better to erase your card by formatting it in the camera instead of using your computer to do it.

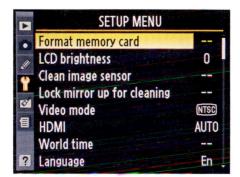

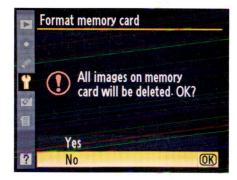

LCD BRIGHTNESS

LCD brightness adjusts the brightness of the monitor. If it's particularly bright outside you could try increasing the brightness if you're having trouble seeing the monitor clearly.

CLEAN IMAGE SENSOR

The D90 has the extremely useful ability to clean the sensor itself. With an SLR camera dust and dirt will eventually get inside the camera and find their way to the sensor. Having a self-cleaning sensor can help avoid unwanted dust spots in your pictures.

The "Clean now" choice lets you clean the sensor whenever you want.

The "Clean at" option allows you to tell the camera when to automatically clean the sensor. You can have it clean the sensor when the camera is turned on, when it's turned off, or both. You also have the option to turn off the automatic cleaning. I don't think it hurts to have it clean the sensor at startup and shutdown, although if I just wanted to pick one I'd go with cleaning at Startup. Then the sensor's cleaned right before you want to start taking pictures.

LOCK MIRROR UP FOR CLEANING

This mirror lock-up function is used when you want to clean the sensor yourself. See Part I: Section D for more information on sensor cleaning.

After you select "On" press the shutter release button all the way down, as though you were taking a picture. This will expose the sensor for cleaning. When you're finished inspecting or cleaning the sensor turn the

camera off. When you turn the camera on again you'll be back to regular camera operations.

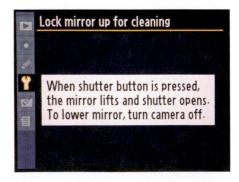

VIDEO MODE

When connecting the D90 to a television or other video device select the setting appropriate for the device. See the end of Part 1B for more information using a video cable.

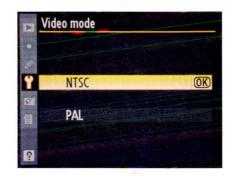

HDMI

You can also connect your D90 to and HDMI device using a type C mini-pin HDMI cable. An HDMI cable is not included with the camera and must be purchased separately. By default the HDMI menu setting is on Auto. This means the camera will automatically choose the correct HDMI format for the device it's attached to. You can also choose the HDMI format yourself. See the end of Part 1B for more information using an HDMI cable.

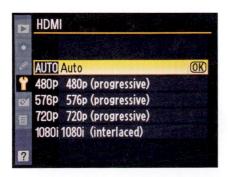

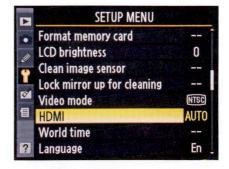

WORLD TIME

You set this info when you first turned on the D90 and did the set-up steps. If you need to change your time zone or adjust the date format you can do that here.

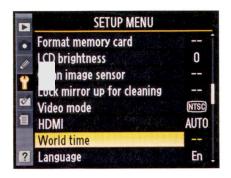

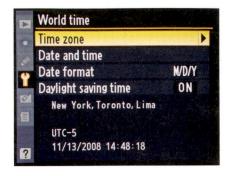

LANGUAGE

Language was selected when you initially set up the camera. However you can always change it if you would like the menus and messages displayed in a different language.

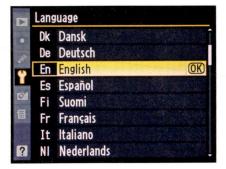

IMAGE COMMENT

Image Comment allows you to attach a text comment to your images. This comment is stored as part of the image along with shooting data such as aperture and shutter speed.

When you go to input a comment you're given a "keyboard" to spell out your comment (up to 36 characters long). Press to enter letters. Press along with a direction on the multi selector to move the cursor for inserting or deleting a letter. Press to delete a highlighted letter. Press OK when you finish your comment and it will be saved.

To have the comment attached to future pictures you take (it can't be attached to photos already taken) move down to "Attach comment" and press the multi selector right to check the box. You can always go back and uncheck the box (comment is still saved) if you no longer want it attached to photos.

In the playback mode one of the detail screens has "COMMENT" listed at the bottom (no comment attached for this photo).

AUTO IMAGE ROTATION

If you turn "On" Auto Image Rotation the D90 will sense the orientation of the camera (horizontal or vertical) and record this information with the image. The benefit comes when you look at the photos on your computer. The vertical pictures will be correctly oriented instead of you having to turn your head to see the photo or spend time rotating all the vertical pictures yourself. I would definitely have this setting turned on.

IMAGE DUST OFF REF PHOTO

Image Dust Off Ref Photo is related to dust and sensor cleaning. You can use this option to take a photo of a white object with no detail. The data captured in the photo can be used by Nikon's Capture NX software to identify and remove dust from your images. This data can only be used by Capture NX.

BATTERY INFO

The Battery Info screen gives you a current reading of the charge of your battery, how many photos you've taken on this charge and the overall life of the battery.

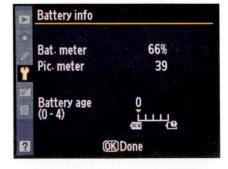

GPS

You can connect a GPS unit to the accessory port at the bottom of the left side of the D90. The GPS device will tell the camera the location of where you took each photo.

The GPS device cannot record information if the camera's meters turn off. The Auto Meter Off controls whether the meters will turn

off as they usually do, or if they will stay on the whole time the GPS is attached. "Enable" will allow the meters to turn off automatically. "Disable" will keep the meters on, maintaining the connection with the GPS unit. However, by leaving the meters on all the time the battery will be drained faster.

FIRMWARE VERSION

The firmware screen tells you what version of firmware the camera is using. Unless Nikon releases an update for the D90 firmware, both A, B and L will stay at 1.00. No need to do anything here.

RETOUCH MENU

The Retouch Menu offers a set of options for adjusting your images while they're still in the camera. Pretty convenient! After selecting one of the retouch items you choose the photo from your memory card that you want to adjust. After the retouching is finished, the D90 will create an adjusted copy of your photo. You aren't actually changing the original photo, so you can always go back to it if you don't like how the retouched image

turned out. When you play back your images the retouched photos will have an icon in the top left to tell you it's a retouched photo.

D-LIGHTING

D-Lighting will brighten the shadows in your images.

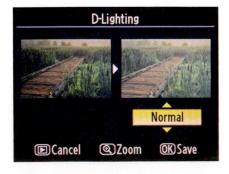

Select your image then choose from a low, normal, or high amount of D-Lighting. Use your original image on the left as a measure of how much D-Lighting will change your photo.

RED-EYE CORRECTION

The D90 will attempt to detect red-eye in photos where flash was used. This tool won't let you select an image if the flash wasn't used. If the camera can't detect red-eye it won't create a corrected copy. The camera will show you a preview before saving a copy. To check the quality of the results you can use the and buttons to zoom in/out then use the multi selector to move around the image.

If no flash was used there will be an X on the photo to tell you that you can't select it.

TRIM

Trim gives you the ability to create cropped versions of your photos.

After selecting your photo, choose the ratio for your cropped photo. Turn the command dial to cycle through the three ratios available (3:2, 4:3, 5:4). 3:2 is ratio for your original photo.

¥3424×2568

3:2 Ratio

4:3 Ratio

5:4 Ratio

After you've chosen the ratio, press the and buttons to increase or decrease the size of the crop. You can use the multi selector to move the crop box around. While you can carefully position the crop box, you can't fine-tune the size of the crop any more than what the zoom in/out buttons allow.

MONOCHROME

The Monochrome option gives you three settings to choose from: black and white, sepia, or cyanotype. A monochrome image is either black and white or only made up of varying tones of one color. The sepia and cyanotype options let you adjust the saturation. Experiment with different photos to see what works for the different monochrome options.

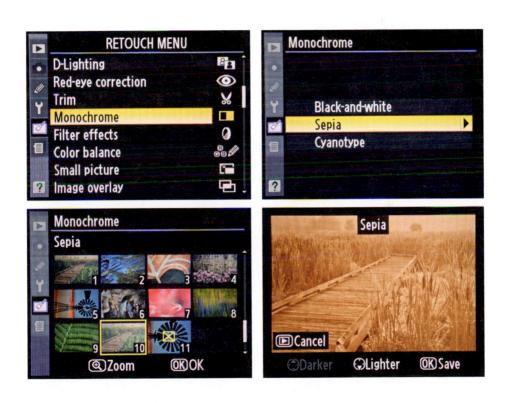

Sepia tone images have a reddish-brown appearance.

Cyanotype images are blue-tinted.

FILTER EFFECTS

Filter Effects offer a variety of filters that affect the colors in a photo. Consider the colors and subject of your photo when deciding which filters to try.

The Skylight Filter adds a little warmth to photos by removing blue. The Warm Filter adds more warmth than the Skylight Filter.

The Red Intensifier creates stronger red tones and the Green Intensifier increases green tones.

The Blue Intensifier strengthens the blues in an image. With the Cross Screen Filter bright areas become the center of a star pattern with lines radiating outward. You can choose how many star points there are as well as the length of the points.

COLOR BALANCE

You can use the Color Balance Filter to add an overall color cast to a photo. Use the multi selector to move the black dot to the area of color that you'd like to add to the image.

Above is the original image.

Extreme green and magenta color balance adjustments.

Extreme blue and red color balance adjustments.

SMALL PICTURE

Are you shooting at the high quality JPEG setting, but have a photo you'd like to e-mail to a friend? No problem, just use the Small Picture Tool to create a smaller version of your photo. Then, as soon as you download your photos, you can attach that image to an e-mail.

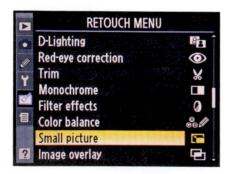

First, choose the size for your smaller version (image sizes are listed in pixels), the select the photos you want to use.

The D90 will confirm that you want to process the selected images, then save the new smaller size. Any image produced by the "small picture" process will have a gray border around it so you know it's not a full size photo.

IMAGE OVERLAY

Image Overlay is an option for blending or combining two RAW photos. JPEGS can't be used for overlays. Press OK to go to the thumbnail view to pick a RAW file. After selecting your first image, repeat the process for choosing a second image. After you have photos for Image 1 and Image 2, you can use the multi selector to adjust the numbers below the thumbnails. These numbers adjust the density of each photo.

NEF (RAW) PROCESSING

The RAW Processing is used to create an adjusted JPEG copy of your RAW photo.

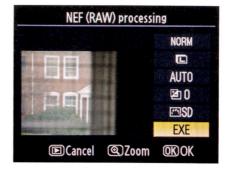

After selecting the photo to adjust you have a number of options. Let's work from the top down. First, choose the JPEG quality and then the size. Next you can change the white balance. After white balance you can adjust the image brightness by changing the exposure compensation. The final choice (above EXE) is to optimize the image with options such as neutral, softer, vivid, and black and white. When you're done with all your adjustments go down to EXE and press OK to save the JPEG copy.

QUICK RETOUCH

Quick Retouch increases the contrast and saturation and brings out details in areas of shadow.

You can choose from a low, normal, or high amount of retouching. Your original photo is shown on the left so you can compare it to how the retouched version will look.

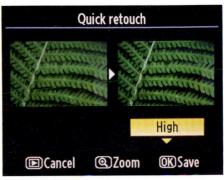

Press OK to save the retouched version. You're then switched to Playback Mode to view the retouched image. This will happen when you create a retouched photo with any of the tools.

RETOUCH MENU Color balance Small picture Image overlay NEF (RAW) processing Quick retouch Straighten Distortion control Fisheye

STRAIGHTEN

The Straighten tool makes it easy to fix a tilted horizon line.

After selecting your image all

you need to do is move the yellow marker left or right on the scale until your photo is straight. You can press left or right on the multi selector or turn the sub-command dial to make your adjustments.

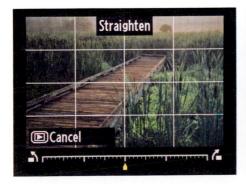

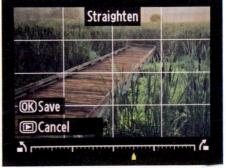

DISTORTION CONTROL

If a wide angle lens has caused distortion at the corners and edges of your image the Distortion Control may be able to help.

The Auto adjustment is more subtle than the Manual adjustment. Move the yellow marker along the scale to reduce the distortion around the sides of your photo. Use the sub-command dial or press left and right on the multi selector.

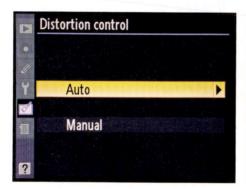

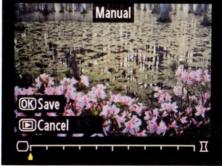

FISHEYE Create the bulging fisheye look from a regular image.

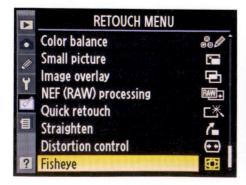

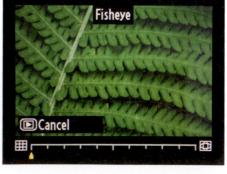

The further you move down the scale the more exteme the fisheye effect. Use the sub-command dial or press left and right on the multi selector.

RECENT SETTING/MY MENU

The last menu actually contains two menus: Recent Settings and My Menu. Recent Settings contains the last twenty menu items (from

any menu) you accessed. So it's always updated with what you've looked at most recently in the menus. This menu can make it easy to find frequently used settings because they're like to be a recent setting.

At the bottom of the Recent Settings menu you find a line that says "Choose Tab". Select this and you can choose between Recent Settings and My Menu.

My Menu gives you more options because it lets you pick exactly what you want to have in the menu. When you go into My Menu you then choose "Add Items".

This takes you to a list of the five menus: Playback, Shooting, Custom Setting, Setup, and Retouch. You can then go into each menu where you'll be given a list of all the items in that menu. You get to

pick and choose which items you want for your My Menu list. Once you have items in your list you can reorder (rank) and delete items.

Section D: Batteries, Memory Cards, and Maintenance

MEMORY CARDS

The D90 uses Secure Digital (SD) memory cards. SD cards come in two varieties: SD and SDHC. The D90 can use both types of cards. SDHC are higher capacity cards than the regular SD cards. SDHC cards start at 4GB capacities and currently go up to32GB.

On SD memory cards there is a slider on the left edge which has "Lock" written next to it. If the slider is in the up position the card is in "write" mode and you can save pictures to it. If you move the slider down, the card will be locked. If a locked card is inserted into the D90 the letters "CHA" will flash in the control panel. If you press the shutter release button you'll see the following message on the monitor: "Memory card is locked. Slide lock to "write" position."

Whenever you get a new memory card you should format it in the D90 before you take pictures with it. To format the mem-

ory card go to the Menus, choose the Setup Menu and then select Format Memory Card. You will also format the card when you want to erase all the photos on it.

On the back of the memory card are the electronic contacts. Take care not to touch these contacts or get them dirty.

To download photos to your computer use either a card reader or connect the D90 directly to your computer with the provided USB cable. When looking for a card reader make sure it can read SDHC memory cards. Often card readers will have numerous slots for various types of cards, or you may be able to find one that is just for SDHC/SD cards.

BATTERIES

- The D90 uses a rechargeable battery. If the battery is completely depleted it will take a little over two hours to recharge.
- It's a good idea to have an extra battery just in case your main battery runs out while you're out photographing. That's especially important if you're traveling. It's no fun to miss the shot because your battery died.

This card reader is designed just for SDHC/SD cards.

- If you're photographing in cold weather the battery will not last as long. Bring along a spare and keep it inside your jacket to keep it warm.
- Keep the protective plastic covers on any extra batteries to protect the battery contacts.

To remove the battery open the battery compartment door and turn the camera right side up. The battery will drop down slightly, coming a little ways out of the camera body. Give the battery a good pull and it'll come out of the camera. The good new is, if you accidentally open the battery door, the battery won't fall out!

MAINTENANCE

CAMERA CLEANING

The following accessories are helpful for cleaning the outside of your camera and lenses:

• Brush: Used to gently brush off dust and dirt particles.

- Blower: Sometimes called a rocket blower, it's used to blow out puffs of air to clean off particles of dust and dirt.
- Microfiber cleaning cloth: Used for wiping smudges and fingerprints off the front of your lens and the monitor.

If there is dust, dirt, or other particles on the front of your lens brush or blow them off first. Then use a cleaning cloth for smudges on the glass. You don't want to use the cloth first because if you rub the particles around on the front of your lens they may scratch the glass.

If you're photographing at the beach, or somewhere else near saltwater, wipe down your gear at the end of the day. Dampen a cloth with regular water and wipe off all camera and lens surfaces (especially the front of the lens). The salt spray can be damaging to your equipment if it's not cleaned off.

KEEPING YOUR SENSOR CLEAN

One major difference between compact digital cameras and digital SLRs, like the D90, is that you can attach different lenses to the camera. However, taking lenses on and off the camera exposes the sensor to dust and dirt. If tiny pieces of dust and dirt land on the sensor, they will appear as little black specs on every picture you take.

One of the great features of the D90 is the self-cleaning sensor. To see the sensor cleaning options go to the Menus, choose the Setup Menu, then go down to Clean Image Sensor. There is also information about this setting in Part I: Section C. Even though the sensor will clean itself, it's still a good idea to do what you can to help keep it clean.

- Turn the camera off before changing lenses (when the camera is on the sensor has a static charge which can attract dust and dirt).
- Keep the camera pointing down when changing lenses (this avoids the potential for any particles falling into the camera and making their way onto the sensor).
- · Minimize the amount of time a lens is not on the camera (if you are

switching lenses, have the next lens ready to put on the camera).

- · Don't remove the lens if you don't need to (when you're done photographing you don't have to remove the lens to store the camera)
- Don't worry! The sensor won't start attracting dust the second it's exposed to outside air, but following these suggestions and using the self-cleaning sensor option will go a long way toward keeping your sensor clean.

Go outside on a day with a clear blue sky. Set your exposure mode to Aperture Priority and choose f/22 for your aperture. Point the camera at the sky (it doesn't matter if it's in focus) and take a picture. Review the photo on the monitor by zooming in or look at it on your computer enlarged to 100%. If you see any dark specs that's dust on the sensor.

SENSOR CLEANING

Of course nothing is perfect and even with the self-cleaning sensor you may eventually end up with dust on the sensor that can't automatically be removed. If this happens, you have a couple of options: send the camera to Nikon for sensor cleaning or find a local camera store that cleans sensors. Another option is to clean the sensor yourself. This may see a little daunting at first, but if you take your time and be careful you'll get the hang of it after a few times.

There are two methods for sensor cleaning: wet and dry. Wet cleaning involves using a special swab, putting some cleaning solution on it, then wiping the swab across your sensor. Dry cleaning uses a brush which spins in order to pick up an electric charge. You then brush the sensor and the electric charge attracts dust particles to the brush and off your sensor. I find the dry cleaning method simpler and quicker. It's also easier to do when travelling. If I have a particularly stubborn spot on my sensor, then I would use the wet cleaning method. One company that makes products for both types of cleaning is Visible Dust (www.visibledust.com).

I wouldn't worry too much about manual sensor cleaning. Take advantage of the sensor cleaning option in the D90 and see how good a job it does keeping dust off the sensor.

The Software

The Software

After you've taken a bunch of photos you'll want to get them on your computer. Nikon offers a few software programs that you can use to download, organize, and adjust your photos.

- Nikon Transfer (downloading photos)
- Nikon ViewNX (organizing and viewing your photos)
- Nikon Capture NX2 (adjusting JPEG and RAW files)

Nikon Transfer and Nikon ViewNX are on the Software Suite CD that came in the box with your D90. You can use the Software Suite CD to install these two programs. Nikon Capture NX2 must be purchased separately. Its regular price is \$180, but you can likely find it for less through online merchants. You can also download a 60-day trial version of Capture NX2 from Nikon's Capture NX web site (www.capturenx.com). In this section we'll look at what each of these programs has to offer and how to use them.

BUILDING AN IMAGE LIBRARY

Now that computers have become the storage devices for our photos it's important to have a system that will enable you to easily find them. Also critical is having a backup copy of your photos. No longer is there a shoebox or drawer with the negatives of our photos. If you just have one copy of your digital photos and something happens to them your pictures are permanently lost.

Before we look at downloading and viewing your pictures, let's think about where to put your pictures on your computer. I'd suggest having one folder named Photos or Pictures (your computer may already have created a folder with such a name). Then place all your photos inside that folder. When you need to find a photo you'll know right where to look because they'll all be in the same place. You may also want to further organize your photos by creating sub-folders within your main Pictures folder. What you name these sub-folders depends on how you want to group your photos. You could create folders for different subject matter such as family, vacation, landscapes, flowers, portraits, etc. Another option is to group by date, making sub-folders for each month. or perhaps you want to group your photos by where they were taken. Or you may decide it's easier to leave all the photos in one folder and not group them at all. How you organize them is up to you. What's important is to pick a system that works for you. Having all your photos in one main folder will make it much easier to find them.

One method for grouping your photos is by category.

To backup your photos there are a variety of storage devices available including CDs, DVDs, and external hard drives. I recommend using an external hard drive. They're compact, they're portable, and you can get lots of storage space for little money. You want the backup copy of your photos to be the same as what's on your computer. If you reorganize or delete the photos on your computer, it's easy to update an external hard drive as well, whereas with a CD or DVD you can't change the information once it's written. There are rewriteable CDs and DVDs, but they're not as reliable and I wouldn't recommend using them for long-term storage/backup. Also, if you use CDs/DVDs for backup don't put them in a closet and forget about them. Eventually CDs/DVDs are likely to be replaced by another storage media. Think back to when you used floppy disks. If you had a floppy disk now you'd have a hard time finding a computer to read it. When the next media format comes along you'll want to transfer your

backed up photos from the old medium to the new one. Whichever backup method you use, it will give you peace of mind knowing you have a duplicate set of your photos.

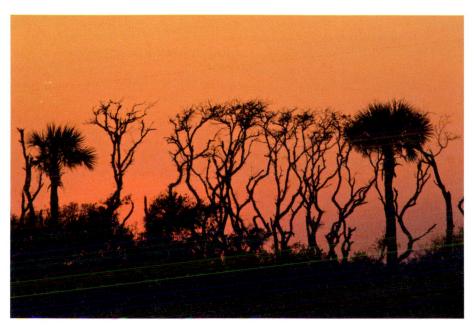

NIKON TRANSFER

Nikon Transfer offers a quick and easy way to transfer (download) photos from your memory card to your computer. But it does more than just download. Nikon Transfer can also rename your photos, automatically create a backup copy, and add IPTC info (more on that later). To get ready to download the first thing you do is connect your memory card to your computer. You can do this by using a card reader or by connecting the D90 directly to your computer. I'd suggest using a card reader because it's generally faster and doesn't use your camera's battery.

Here's how to set up using either method:

Downloading using a card reader

- 1. Turn your computer on.
- 2. Connect the card reader to your computer.
- 3. Remove the memory card from your D90.
- 4. Insert the memory card into the card reader's slot for SD cards.

Downloading using your camera

- 1. Turn your computer on.
- 2. Turn off the camera. Leave the memory card in the camera.

- 3. Connect the camera to the computer using the USB cable that came with the D90.
- 4. Turn on the camera.

After you have your memory card connected to the computer (via a card reader or the camera), open the Nikon Transfer program. When you first start the program you'll see a window that has three sections: Options, Thumbnails, and Transfer Queue. Next to each one is a dark circle with a triangle in the center. Click on any of the triangles to expand the information in that section.

QUICK DOWNLOAD INSTRUCTIONS

If you're not interested in Nikon Transfer's options and features and just want to download your photos here's what to do: just click the Start Transfer button in the bottom right of the Nikon Transfer window. That's it! All the photos on your memory card will be downloaded. I do suggest you check which folder is chosen as the primary destination (Options section, Primary Destination tab). This tells you where Transfer is putting your photos so you know where to find them. You can also change the destination folder.

OPTIONS SECTION

First click on the triangle next to Options. You're now presented with a row of tabs. Let's take a look at the choices for each tab.

Source

In the Source tab you choose where you're downloading the pictures from. Once the camera or card reader is connected a box will appear in this section identifying it. Click on the box to select it.

Card reader connected (your card reader may have a different name).

Embedded Info

The Embedded Info tab let's you add IPTC information to your photos when they are downloaded. IPTC information is stored within your image file. Remember when you play back photos and you can see shooting information about the pictures (aperture, shutter speed, ISO, white balance, etc.)? This shooting information is automatically stored as part of your image file. IPTC info works the same way, but you get to choose which information to add. Once you add it, the information becomes part of the image file, but you can change or delete it later.

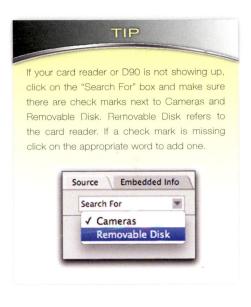

Using this feature of Nikon Transfer is a quick way to add the same information to all the photos you're downloading. However, it's not your only chance to add IPTC information. You can also add (or change) IPTC info using Nikon ViewNX and Capture NX.

Before we look at IPTC info, check the box next to "Embed ICC color profile during transfer."

Click on the Edit box to bring up the IPTC window.

XMP/IPTC	Preset	
		Check all
☐ Tags		n
Label	0 (None)	
Rating	***	0
Keywords		0
☐ Description		
Description		0
Title		0
Copyright Notice		0
☐ Contact		
Creator		0
Creator Job Title		P
Creator Address		0
Creator City		
	Cancel	OK
	☐ Tags Label Rating Keywords ☐ Description Description Title Copyright Notice ☐ Contact Creator Creator Job Title Creator Address	Label ((None) Rating * * * * * * Keywords Description Title Copyright Notice Creator Creator Job Title Creator Address

The IPTC information is grouped by categories. You'll need to scroll down to see them all. It's important to remember that whatever information you add here will be added to all the photos you download at this time. So you want to make sure you're adding information that applies to every photo. Adding specific information to select photos is more easily done using ViewNX or Capture NX.

You can create a preset to save a set of IPTC information so you don't have to reenter it every time you download photos. By saving a set of your basic contact information, you can save time when downloading. Here's how:

- 1. Click the New button.
- Enter a name for your set of info, such as Basic Info.
- 3. Press the Enter key.
- 4. Fill in the following information:
 - a. Description section: Copyright Notice:(c) 2009 {your name}
 - b. Contact section: add as much info as you'd like
- 5. Click OK

Now you can choose your preset from the drop down menu. By choosing this preset your contact information will be automatically embedded in your photos. You won't have to type it in every time!

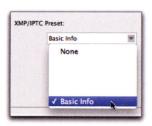

PRIMARY DESTINATION

In the Primary Destination tab you choose where your photos will be downloaded on your computer.

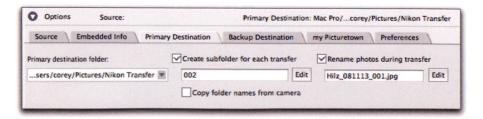

You also have a couple other options available. Whether you use them is personal preference.

Create subfolder for each transfer:

You can have a new folder created every time you download photos. This keeps the photos from each download in a separate folder instead of having all your photos together in one folder. Click on Edit to change how the subfolders are named.

Rename photos during transfer:

Use this option to change the name of your photos. Click on Edit to see the choices available.

Here's an example of how you could rename your photos: Hilz_080326_001.jpg, Hilz_080326_002.jpg, Hilz_080326_003.jpg, etc.

This renaming uses my last name (you could also use your initials), the date the photo was taken, and a string of numbers that counts up one for each photo. This method allows you to identify who took the photo and when it was taken just by looking at the file name. It will also keep your files in chronological order, which is useful if you have many photos in the same folder.

Here's how to set up the file options to rename your files in this way:

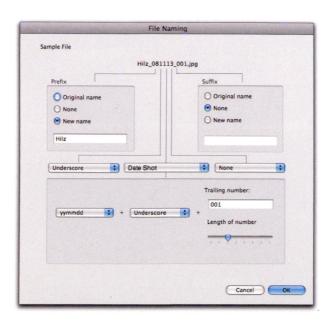

BACKUP DESTINATION

The Backup Destination tab lets you set up Transfer to automatically download your photos to a second location. Simply check the box next to "Backup photos," then choose the folder where you want your

photos backed up. Your photos should be backed up to a different hard drive than the one that has your original photos, because if something happens to your primary hard drive, then you'll still have a copy of your photos on the second hard drive.

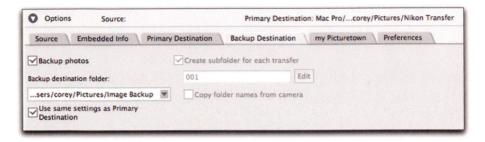

MY PICTURETOWN

The my Picturetown tab can be used if you have a my Picturetown account. My Picturetown is a Nikon service for storing your photos online. The options here allow you to upload your photos to your my Picturetown account. You can find out more information about my Picturetown at www.mypicturetown.com.

PREFERENCES

The Preferences tab includes a variety of options regarding how photos are downloaded and what Transfer does after your photos finish downloading.

THUMBNAILS SECTION

Next let's look at the Thumbnails section. Click on the triangle icon next to "Thumbnails" to show the photos on your memory card. If you want to hide the Options section just click the triangle icon next to "Options."

You'll notice that each of the thumbnails has a checkbox under it. Every photo that is checked will be downloaded. If there are some photos you don't want to download click on the checkbox to remove the check.

The drop down menu next to "Group" offers a few options for sorting the photos on your memory card.

Grouping options

Shooting Date: Photos are grouped by the date they were taken. This option makes it easy to find photos that were taken on a particular day.

Extension: Sorts photos by the file extension such as JPG and NEF.

Folder: If your memory card has photos in multiple folders, the thumbnails are grouped by the folder they're in. Unless you've set up multiple folders on your D90, all your photos will be in one folder.

If you want to download all the photos from your memory card these sorting options aren't necessary. They can be a useful feature if you want to choose certain photos.

Above the thumbnails is a set of icons that you can use to automatically select, deselect, or delete certain photos.

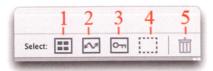

- 1. Selects all photos.
- 2. Selects photos that have been marked for transfer in the camera.
- 3. Selects photos that have been marked as protected in the camera. This means that when reviewing photos you pressed to protect the photo from being deleted. Protected photos will have the key icon under the photo's file name.

This file is protected.

- 4. Deselects all photos.
- 5. Delete selected photos. It can be a little confusing as to what Transfer considers a "selected photo." If a photo has a check in the checkbox this does **not** mean it's selected for deletion. To select a photo you must click on the thumbnail itself until the border around the photo turns light gray.

File _DSC8317.NEF is selected.

After clicking on one or more of the thumbnails, the trash can icon darkens and you can click on it to delete the selected photos.

TRANSFER QUEUE SECTION

Click on the triangle next to Transfer Queue to show a list of all the photos that will be downloaded. The photos listed here are the same ones checked in the Thumbnails section. The queue tells you the names of the photos, the size of each image file, where it's coming from, and where it will be downloaded. If it says "(Multiple)" under Destination it's because you chose to have the photos backed up so they'll be downloaded to more than one place. If you change your mind and don't want to download all the photos listed, just click on the "X" at the far right to remove photos from the queue.

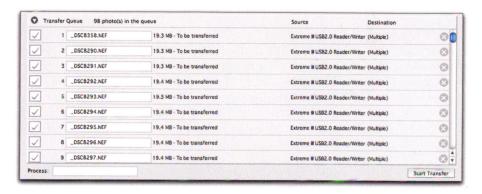

Now you're ready to download! Click the Start Transfer button in the bottom right of the window. The "Process" box in the bottom left will list where Transfer is in the download process.

NIKON VIEWNX

After you've used Nikon Transfer to download your photos, use Nikon ViewNX to look at your photos, organize them, and even attach them to an e-mail. Let's see what ViewNX has to offer.

Down the left side of the ViewNX window are three boxes: Folders, Metadata and Quick Adjustment. To show the information palettes for these sections click the "+" above the names in the boxes. The "+" turns to a "-" when the information for that section is open. You can only view the information for one section at a time. To close the displayed information, click on the "-."

Whenever any of the palettes are open four icons are always displayed at the top: left arrow, right arrow, folder with an arrow, and folder with a heart.

- Clicking the left and right arrows allows you to navigate to folders you have already viewed.
- If the arrow is light gray it means there are no more previously viewed folders in that direction.

- If the arrow is dark gray you can also click and hold on the arrow to bring up a list of folders you've viewed. This allows you to pick a previously viewed folder by name instead of having to click the arrows to get to it.
- Clicking the folder icon with the arrow will take you up one level higher in the folder tree hierarchy.
- Clicking the folder icon with the heart will show a list of your "favorite folders".

FOLDERS

The Folders palette shows you a list of your "favorite folders" and a folder tree of the folders on your computer. Use the directory to locate the folder with your photos. Once you click on a folder the photos inside will be displayed in the browser to the right. If the folder does not contain any photos you'll see the message: "There is no file to display." To add a folder to the favorites list click and drag a folder from the folder tree up to the favorites section.

METADATA

The Metadata palette has two halves. The top half is information about the settings on your camera when you took the photo. Click the triangle next to each category (File Info 1, File Info 2, Camera Info, Exposure, Flash, Image Settings, GPS) to show or hide the information. The information in these categories can't be changed.

The bottom half is the XMP/IPTC Information which probably looks familiar. It's the same set of groups/information that was available in Nikon Transfer. If you added any IPTC information to your photos when you downloaded them with Transfer you'll see it here.

Click the triangles to expand each group of information. After entering your information click Apply at the bottom. If you click a different photo without first clicking Apply the following message will pop up asking if you want to save the IPTC info you've added:

If you click No, any IPTC information you just entered will be deleted. Unfortunately there's no way to "cancel" and continue entering information. If this message popped up because you accidentally clicked another photo it would be best to choose Yes to save the info, then go back and enter additional information.

QUICK ADJUSTMENT

The Quick Adjustment palette gives you the opportunity to make limited adjustments to your photos. When a JPEG picture is selected you'll only be able to change the D-Lighting HS and Color Booster settings at the bottom. If you took a picture in the RAW file format (NEF file extension) you can use all the adjustments in the palette. Once you're done making adjustments click Apply.

 Exposure Compensation: Move the slider to make your photo lighter or darker.

- White Balance: Change the white balance setting.
- Picture Control: Change how the colors are rendered with settings such as Neutral, Vivid, and Monochrome.
- D-Lighting HS: Brings out more detail in the shadow and highlight areas of your image. The low, medium or high options allow you to choose the strength of this adjustment.
- Color Booster: Increases the intensity of the colors. If "People" is selected then skin tones are not affected. "Nature" affects all colors.

TOOLBAR

There are a few ways you can have the toolbar displayed. To see the options available choose Customize Toolbar from the Window menu.

Depending on how much space you want the toolbar to take up you can have it displayed as icons, text, or both. Also you can select Use Small Size to further minimize it. The Customize option lets you remove items from the toolbar. If you decide you don't want to see the toolbar at all you can hide it by unchecking Toolbar in the Window menu (Mac: choose Hide Toolbar).

Let's take a look at what the buttons in the toolbar offer:

Launches Nikon Transfer.

Focus Point places a set of red brackets on your photos to show where the camera focused. The brackets will only appear if you used auto focus. If manual focus was used then no brackets will appear. To hide the brackets click the button again.

This button would be darkened if the photo has a voice memo attached to it. The D90 doesn't have the ability to record voice memos.

Use the Rotate button to turn your photo 90 degrees clockwise or counterclockwise. Click and hold the button to choose which direction you want to rotate your photo.

Clicking this button will open the selected photo in Nikon's Capture NX software.

You can also print your photos directly from ViewNX. Click the print button to bring up the print dialog box which contains a basic set of printing options. You can print more than one photo at a time, so select the photos you want to print before choosing Print from the toolbar.

The Print As drop down menu offers three ways to print your photos:

- 1. Full Page: Fills the selected paper size with the photo.
- 2. Index Print: Print multiple images on each page. You choose how many pictures on a page.
- 3. Standard Photo Sizes: You pick from a set of print sizes (4 \times 6, 5 \times 7, 8 \times 10, etc.).

Check the box next to Print Photo Information if you'd like details about your photo printed below it. Click the "Settings..." button to see what information can be added.

To change the paper size and printer click the "Page Setup..." button.

The e-mail button brings up options for attaching one or more photos to an e-mail. ViewNX will use your e-mail software to create a new message and attach the selected photo(s) to it.

"Send as:" options:

Multiple photos means each photo selected will be a separate attachment to the e-mail. If index print is selected multiple photos will be placed on one page; you can choose how many photos per page. Each page of the index print is a separate attachment.

0 sec.

The SlideShow button offers a quick way to create a slide show to share your photos. Before clicking the button select the photos you want to include in the slideshow. ViewNX won't automatically play all the photos in the folder. For example, if you only have one photo selected the slideshow will just play that single photo.

The SlideShow dialog box gives you a variety of options for controlling how the slide show will run.

> Toolbar: At the bottom of your monitor you can choose to have a toolbar, which allows you to control the progress of the slide show as well as what information is shown on the screen.

Transitions: You can choose if you want an effect such as fading or movement of the photos when the picture changes.

Repeat slideshow Don't show this dialog again Cancel OK

Toolbar Show Slide Controls

M Show image information

Show each slide for 3

Transitions No Effect

Show Histogram

Using the checkboxes you can also choose how much, if any, additional information you have displayed about the photo during the slide show. During a slide show for family or friends you may not want to have any of the information visible. If you are using the slide show to review your photos you may find it useful to have some of the technical information displayed.

When the slide show finishes it will exit automatically unless you check "Repeat slide show."

During this slide show the toolbar is visible at the bottom and all possible information is displayed.

Use the Convert Files button when you want to save a copy of one or more photos. You can use this feature to save an exact copy of a photo or to save a copy of a dif-

ferent size. This is useful when you've taken the photo at the highest quality setting on the D90 and the file is too large to e-mail. You can use Convert Files to save a smaller copy and then send the copy with the e-mail.

- "File format" gives you the option to save the copy of your photo as a JPEG or TIFF. JPEGs are compressed, while TIFFs are not. This means TIFFs will take up more space on your hard drive. Saving as a JPEG is fine for most uses.
- If you want to change the image size you can choose the pixel dimensions for the longest side and ViewNX will maintain the original proportions of the image.

	JPEC	•			
Use LZW Cor	mpression				
Original Image	Size: 1800 x	1196 pixels			
Change the	image size				
Long Edge:	1800	pixels —			
Short Edge:	1196	pixels —			
Compression R	atio: Good Or	ality			
annument and a second)	-
		1			
Remove cam	nera setting in	nformation			
	era setting in				
	P/IPTC inform				
Remove XMF	P/IPTC inform color profile			Browse	
Remove XMF Remove ICC /Users/corey/P	P/IPTC inform color profile	ation	CNO		
Remove XMF	P/IPTC inform color profile	ation	Na	Browse	
Remove XMF Remove ICC /Users/corey/P	P/IPTC inform color profile Pictures subfolder fo	ation			

- "Compression Ratio" will be available if you are saving as a JPEG. I recommend a Good or Excellent Quality setting
- For most uses there is no need to remove camera setting information, XMP/IPTC information, or the ICC color profile.
- The options at the bottom of the dialog box allow you to choose where to save the photo(s), to create sub-folders each time files are converted, and to rename the files.
- In the bottom left of the box ViewNX tells you how many photos will be converted.

LABELS

At the bottom of the window is a row of numbers.

The numbers are for labeling a photo with a number/color combination. One way to use the labels is to assign a category to them. "1" could be family photos, "2" landscape photos, "3" wildlife photos, and so on. To change the label assigned to each number go to the Edit menu and choose Options (Mac: choose Preferences from the ViewNX menu). Click "XMP/IPTC Information" from the list on the left. To

change the labels from the defaults (Red, Orange, Yellow, etc.) uncheck the "Use default values" box.

ADDING LABELS

- To label a photo simply click one of the numbers.
- You can only assign one label to each photo.
- To change the label click a different number.
- To remove the label click the zero.

RATINGS

Also at the bottom of the window is a row of stars.

The stars are for assigning a rating to your photos. They can be used to rank the quality of your photos. A one-star rating might be a low quality image and a rating of five stars could be one of your best photos.

Adding Ratings

- To add a star rating click the number of stars you want to assign to a photo. For example, if you want to add three stars you just need to click the third star.
- To change the star rating click a different star in the row.
- To remove the rating click the circle icon to the left of the first star.

When you add a label or rating it will appear under the thumbnail photo. If you already assigned a label and/or rating (when downloading or using the IPTC palette) they will appear under the thumbnail automatically.

This photo has been labeled with a "1" and been given a three-star rating.

VIEWING AND SORTING

Under the Nikon Transfer button in the toolbar is a drop down menu which offers four ways to display your photos.

In each view you'll have the following controls at the bottom of the window.

The left half has the label and rating controls discussed above. In the middle are two arrows which you can use to move to the previous or next photo. If you want to delete a photo click the trash can on the right.

THUMBNAIL GRID

Thumbnail Grid only shows your photos as thumbnails. This view allows you to see the most pictures at once. Double-click a thumbnail to view it full screen.

IMAGE VIEWER

Image Viewer places a strip of thumbnails across the top with the selected image shown below. This arrangement allows you the most flexibility because you can scroll through thumbnails while getting a better view of your selected image.

Between the thumbnails and the large image are a series of display controls:

Click the 'i' button to show or hide a box with metadata, including exposure information and keywords.

The histogram button shows/hides the histogram for the displayed image. Once the histogram is displayed you can click the bar just to the right of the button to show options for how the histogram is displayed.

To adjust the size of the image move the slider on the right. If you want to check the sharpness of your photo move the slider to 100% (the image may now be larger than the viewing

space and you'll have to scroll around to see different parts of the image). To make the image fill the viewing space, click the box icon above the left end of the slider.

FULL SCREEN

Full Screen fills your monitor with the selected photo. All menus and most icons are removed to give as much space as possible to your photo. The sorting options are taken away since there's just a single image. Use this view when you want to see a photo as large as possible.

The controls at the top of the screen are the same as those in the

Image Viewer mode. You have the Info button, Histogram button and image size slider.

THUMBNAILS AND FULL SCREEN

This display mode can be used if you have two monitors. One monitor will show the thumbnails and toolbar, the other will

be a full screen view of the selected photo.

- 1. Press the Escape key.
- 2. Click on the "X" in the top right corner of the screen.
- 3. Press Ctrl+W (Mac: Cmd+W)

TIP

If you have two monitors, ViewNX will automatically use your second monitor to show an image full screen in the following cases:

- 1. When you double-click on a photo in Thumbnail Grid mode.
- 2. When you double-click the large image in Image Viewer modo.

To change this default behavior go to Edit > Options, then choose the Viewer section (Mac: ViewNX > Preferences).

TIP

When you are in Image Viewer or Full Screen mode you can easily view your photo at 100% by holding down the Shift key. While at 100% click and drag the photo to move it around and examine the details.

Above the thumbnail display are a series of buttons that give you different ways to filter and sort your images.

FILTERING BY NUMBER LABELS

The number icons above the thumbnails look just like the numbers at the bottom of the window, but these are for filtering your photos by the number label assigned to them.

For instance, click the 5 to see only those photos labeled with a 5.

You can also create a combined filter by clicking more than one number.

This combination would show you all photos labeled with a 2, 5, or 8.

0 1 2 3 4 5 6 7 8 9

FILTERING BY STAR RATINGS

The star icons above the thumbnails look just like the numbers at the bottom of the window, but these are for filtering your photos by the rating assigned to them.

you've clicked on a number).

To see the photos that have three stars click the third star. The window may say "Processing" while ViewNX is filtering. Once done the window will just show photos that have been assigned three stars.

You can also create a combined sort by clicking on more than one star; however, you have to choose a range of star ratings. For example, ViewNX won't let you just pick 1, 3, and 5 stars. You have to pick

numbers that are next to each other such as 1–2, 4–5, and 2–3–4. The following selection means that any photos that have three, four, or five stars will be displayed:

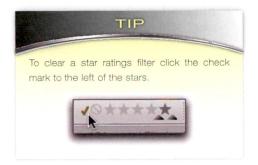

FILTERING BY FILE TYPE

The last filtering option is by file type. From the drop down menu you can choose what type of file(s) you want shown.

NEF = RAW files

JPG = JPEG files

TIF = TIFF files

The default option is "NEF + JPG|TIF," which will show all the file

types. If you want to see photos from only one of these file types select it from the bottom of the list.

CHANGING SORT ORDER

At the end of the row of filtering choices is a drop down menu where you can choose how your photos are ordered. There are a variety of options ranging from alphabetically (Name) to when you took the picture (Date Shot) to the rating or label.

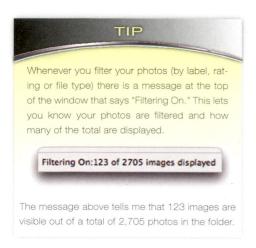

ADJUSTING THUMBNAIL SIZE

Move the slider between the small and large boxes to adjust the size of the thumbnails. You can also click on either box to change the size. This slider is available in the Thumbnail Grid and Image Viewer modes.

CAPTURE NX

Capture NX offers an extensive set of tools to adjust your RAW and JPEG photos. Some adjustments can only be made to RAW files and will not be available when you're working with a JPEG. To give you an introduction to the capabilities of Capture NX we'll look at the features you'll use most often.

Capture NX has a number of palettes arranged on the left and right sides of your screen. Each palette has its name written vertically. Just above the name of the palette is a little box with a + or - in it. These symbols tell you what will happen if you click the box. A plus symbol means the palette will expand and show the contents. If you click a minus symbol the palette will shrink and hide the contents. The boxes down the left side of your monitor probably look familiar. It's a similar arrangement to ViewNX. There are Folders and Metadata palettes and a large Browser palette that is likely filling your screen. Once you find a photo you want to work on double-click on the photo. The Browser palette will shrink to the left side and the photo will fill your monitor.

DEVELOP

After opening your photo you'll first want to make some basic adjustments in the Develop section. The center palette on the right side of your screen is the Edit List. The Edit List will show any adjustments you've made to your photo. You'll be using the Edit List a lot. In the Edit List you have a Develop section at the top. In the Develop section you have sub-groups of adjustments. If you don't see anything under the word 'Develop' click on the triangle next to it to show the adjustments available. What's available will vary depending on whether you are working with a RAW or a JPEG file. A RAW file will have three groups: Camera Settings, Quick Fix and Camera and Lens

Corrections. JPEG files will only have Quick Fix and Camera & Lens Corrections.

Develop options for a RAW file.

Develop options for a JPEG photo.

Click the triangle next to each category to see the adjustments within it. When you click the triangle next to a sub-adjustment you get a list of settings with sliders and drop down menus.

Camera Settings for a RAW file.

The section that is particular to RAW files, Camera Settings, has the following adjustments available:

- White Balance: You can select a new white balance amount from the drop down menu, then tweak it with the Fine Adjustment and Tint sliders.
- Picture Control: You can set your desired color mode, amount of sharpening, tone compression (contrast), saturation and hue.
- Noise Reduction: Move the Intensity and Sharpness sliders to reduce color noise.

The next section in the palette is Quick Fix which is available to both RAW and JPEG photos.

Quick Fix Settings for a RAW and JPEG files.

- Levels & Curves: At the top of the Quick Fix box is Levels and Curves box. A standard adjustment useful for most photos is to bring the black and white sliders in to the edges of the histogram.
- Exposure Compensation: Increase or decrease your photo's exposure (how bright or dark it is).
- Contrast: Increase or decrease contrast.
- Highlight Protection: Move slider to right to retain detail in the brightest parts of the photo.
- Shadow Protection: Lightens shadows to bring out more detail in the dark areas.
- Saturation: Increase or decrease the intensity of the colors.

The third section, available for both RAW and JPEG is Camera & Lens Corrections. However, there are more adjustments available in this

section if you are working on a RAW file.

- Color Moire Reduction
- Image Dust Off (if you took a dust off reference photo with vour camera)
- Auto Color Aberration
- Auto Red-Eve which has an automatic adjustment option
- Vignette Control: If there is vignetting in your photo (darkening around the edges) use this adjustment to reduce or remove it.

Notice as you make these adjustments that there are check box/ circles on the right side of the

Camera and Lens Corrections.

palette. You can uncheck the box or the circle to see what your photo looks like without that adjustment. Checking and unchecking adjustments is a guick way to see a before and after view of your photo.

ADDITIONAL PALETTES

Above the Edit List palette is the Bird's Eye palette. It shows you a

thumbnail of your photo. If you are zoomed in and the photo is larger than the window, the Bird's Eye will show a red box around the part of the picture you are seeing. To move around the photo you can click and drag the red box around the Bird's Eve thumbnail.

Below the Edit List is the Histogram palette. You can view the RGB histogram or the individual color channels.

TOOLBAR

The toolbar is a strip across the top right of your monitor with adjustment tools. The following is an overview of how you can

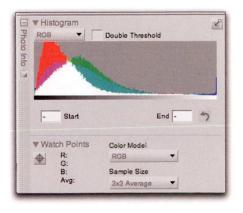

use them to adjust your photos. It's not intended to be step-by-step instructions for how to use the adjustment tools, but an introduction to what Capture NX has to offer.

Direct Select Tool: Use to select objects such as control points, images in the browser and steps in the Edit List.

Hand Tool: If you have zoomed into your image and it's too large to fit on the screen you can use the hand tool to move to different parts of your image. Click and drag on your photo to move it around.

Zoom Tool: The Zoom Tool changes your cursor to a magnifying glass with a "+" inside it. Click on your photo to zoom in. To zoom out press and hold the Alt key (Mac: Option) while clicking on your photo. The magnifying glass will now have a "-" inside it. When you release the Alt (Mac: Option) key you'll be back to "zoom in" mode.

Rotate Tool: Turns a photo 90 degrees clockwise or counterclockwise. Click and hold the button to choose which way you want to rotate the photo.

Straighten Tool: If your photo is askew you can fix it using the Straighten Tool. Perhaps you have a sunset photo where the horizon is not straight. You use the Straighten Tool to draw a line along the horizon, which tells Capture NX that this line should be level. The photo is then rotated to make the horizon straight. Be aware that to straighten a photo cropping is required, so you'll lose some of your photo around the edges. The more a photo must be straightened the more it will be cropped.

Crop Tool: Click and drag to draw a cropping box. After creating a box you can click and drag on the black boxes around the edges to change its size and shape. To move the box (but keep the size of the box the same) click and drag in the center of the box. To complete the crop press Enter, to cancel the crop press the Esc key.

Black, White, and Neutral Control Points: The three eye droppers represent black, white, and neutral from left to right. You can use them to identify black, white, and neutral tones in your image. If you don't actually have areas

of pure black or white in your image using those eye droppers can lead to dramatic, often unwanted, changes in the appearance of your photo. Placing a neutral control point on a neutral or middle tone area will remove color casts from a photo.

Color Control Point: This is a powerful feature of Capture NX. It allows you to selectively adjust individual colors within your photo. They're easy to use and give you a lot of control over retouching your image. You can use control points with JPEG or RAW files. After clicking the control point button, click the color vou want to change in your photo. It could be a person's face, the sky, or a flower. Once you click on your photo four slider bars appear.

When you drag the top slider you'll see a circle appear. As you drag the slider the circle becomes smaller or larger. The size of the circle reflects how large an area you want to adjust. A small circle will change an area close to the spot you chose; a large circle will affect more of the photo. The remaining sliders are labeled B, C, and S. B = brightness, C = contrast, and S = saturation. Using these three sliders you can increase or

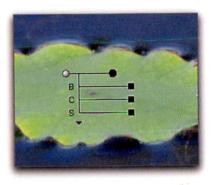

decrease the amount of brightness, contrast, and saturation in your targeted area. You can add multiple control points to a photo.

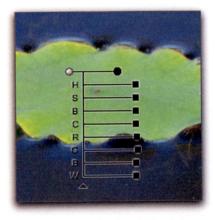

You can access more sliders by clicking on the triangle below the S. This expands the list to include sliders for hue, warmth and the red, green, and blue color channels.

Here's a before and after comparison of a photo adjusted using control points. I used control points to darken the water and the lily pads in the background. I also brightened some of the lily pads in the foreground, to draw more attention to the front of the photo. The largest adjustment was darkening the water which was easy to do by placing controls points on the blue and reducing the brightness.

Original.

Adjusted with Control Points.

Red-eye Control Point: Click on the subject's eye where you want the red-eve removed.

Auto Retouch Brush: Use the auto retouch brush to automatically repair/remove unwanted details in your photos. This brush is great for eliminating dust/sensor spots, blemishes and other small distracting elements.

Selection Control Point: Use selection control points to apply an enhancement to a particular part of your image. Add the enhancement first then select and place a selection control point to adjust where the enhancement is affecting.

Lasso & Marquee Tools: These tools are for drawing selections around certain areas of a photo. Click and hold the button to see all the choices available. Once you select part of your photo, go over to the bottom of the Edit List and click New Step which will let you choose what type of adjustment you want to apply to the selected area.

Selection Brush: You can use the selection brush to paint over areas that you want to change in your photo. Next go to the bottom of the Edit List and click New Step which will let you choose what adjustment you want to apply to the area you painted with the brush. The selection brush can also be used in combination with the Lasso/Marquee, Selection Gradient, and Fill/Remove Tools. You would use those tools first then use the brush to further fine-tune how the effects are applied.

Selection Gradient: The gradient tool allows you to adjust an area of your photo by creating a gradual transition. At one end of the gradation the effect you choose will be very strong and at the other end the effect will be faint. Use the gradient tool to draw a line on your photo from where you want the effect to start to where it should end. Next go to the bottom of the Edit List and click New Step which will let you select the adjustment you want to apply to the gradient area.

Fill/Remove Tool: Clicking on the fill/remove button will select the entire image, then over in the Edit List you can choose what adjustment you want to add by clicking on New Step.

USING NATURAL LIGHT

No matter what you're photographing, the light is a key component. Without light, from some source, you wouldn't have a photograph. It affects the appearance of your subject, creates a mood, and directs the viewer's eye. In this section we'll look at photography using natural light.

TIME OF DAY

What time of day you take a picture outside has an enormous impact on the appearance of your photograph. As the sun moves through the sky the quality of the light changes. Early and late in the day are the best times to be out photographing. Even before sunrise you can have rich warm colors in the sky, lighting up scattered clouds. In the early morning and late afternoon the sun is low on the horizon. When it's at this low angle it throws a

warm light over the landscape and everything from trees to sign posts cast long shadows. As the sun moves higher up in the sky you lose the warm light and long shadows.

SUNRISE AND SUNSET

Look for vibrant colors in the sky at sunrise and sunset. The warm hues of yellow, orange, red, and pink add dramatic color to a landscape. Include any interesting cloud formations that roll through the sky. Some of the best sunrise and sunset photographs are taken before the sun is above the horizon or after it has dropped below the horizon.

Fading color at sunset.

Besides warm light at sunrise, water will also be calm, making it perfect for reflections.

MORNING AND AFTERNOON

For a few hours after sunrise and before sunset, the light is still warm, attractively lighting many subjects. In the morning and late afternoon the sun is lower in the sky.

Late morning offers warm light, as well as a rich blue sky.

In the morning the angle of light is still low enough to produce dramatic lighting.

MID-DAY

The middle of the day is generally the worst time of the day to photograph outside. With the sun high overhead the light is harsh and contrasty. This type of lighting appears flat and is not an appealing look for subjects.

DIRECTION OF LIGHT

FRONT LIGHTING

When the light is coming from behind you (over your shoulder), your subject is front lit. Front lighting is good for showing details because it evenly lights up the subject.

Front lighting throws a warm, but even light on this bow of the boat.

The sun over my shoulder strongly lights the front of the building while the storm clouds above create a dramatic backdrop.

SIDE LIGHTING

Side lighting is when the light is coming from your left or right. You'll find side lighting in the morning and late afternoons when the sun is low in the sky. It's good for emphasizing texture and showing detail. It can help define the shape of many subjects whether you're photographing a landscape or a city. Shadows are more apparent when there is side lighting.

Side lighting brings out the texture of the rocky ground.

The shadows help fill in the right side of the composition and lead the eye through the image.

BACK LIGHTING

Back lighting occurs when the sun is behind your subject. Back lighting can be dramatic. You can use back lighting to create silhouettes. If the backlighting is strong enough it can create a glow around your subject called rim lighting. With backlighting it can be more challenging for the camera to properly expose your photograph. Be sure to use the monitor to review your image and see if you need to make any adjustments.

Use backlighting to create graphic silhouettes.

Backlighting gives a glow to the leaves on the tree and the Spanish moss hanging in its branches.

DIFFUSED LIGHTING

Cloudy days are also a great time to go outside and photograph. Overcast days produce a diffused light that is soft and even. You capture excellent detail in the highlights and shadows of your subject. Diffused light lets you avoid the high contrast of direct sunlight that can be a problem for some subjects. On cloudy days you could spend the whole day photographing outside because you don't have to worry about harsh mid-day lighting.

Diffused light eliminated the possibility of harsh bright spots and allowed me to retain the detail of the pale clematis petals.

Soft light on the chain helped retain detail in the shadows at the top of the image. The isolated composition removes any references for scale. Each link of the chain is at least six inches long.

INCLEMENT WEATHER

If it isn't sunny outside it doesn't mean it's a bad time of day to go out and photograph. Inclement weather such as fog, rain, and snow offer some unique shooting opportunities. Fog can magically transform a landscape. With fog

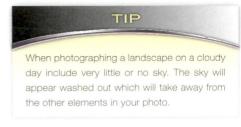

hanging in the air it can make a scene mysterious and moody.

When plants and flower get wet their colors become more saturated. Getting out to photograph right after the rain stops is ideal. Even photographing in light rain is manageable. Just make sure you're dressed for the conditions. Aside from a rain jacket to keep you dry you want to have your camera protected too. While you could bring along a plastic bag, a variety of companies make rain covers for cameras. They include FM Photography (Shutterhat), OP/TECH USA (Rainsleeve), and Kata (GDC Elements Cover).

If you're going out in the snow you definitely want to bundle up. If you stay warm you'll want to stay out photographing longer. It's no fun to stay out shooting when you're cold and wet. Photographing while it's snowing can give your photos a different look with the snow suspended in the air. Or get outside when the snow stops while everything is covered in a pristine blanket of white.

The fog wraps around the trees drawing your attention to the treetops emerging from the mist.

Just after it rained the lily pad is covered with water drops along with a lone frog.

Look for details after a snowstorm, such as this rock at the edge of a frozen pond.

LIGHTING COMPARISON

A location or subject can look quite different depending on the type of lighting. Take a look at these examples and how the feeling of the photo changes with the light.

SIDE LIGHTING VS. FRONT LIGHTING

By moving my position I was able to photograph this small scene with both front lighting and side lighting. In the front lighting photo the azaleas and Spanish moss are evenly lit all the way across the image. From the side the shadows are much more apparent for a more dramatic feel.

Front lighting.

Side lighting.

DIFFUSED LIGHTING VS. DIRECT SUNLIGHT

In these two photos the composition is the same as they were taken from the same spot. All that changed was the lighting. The leaf and water drops were shaded, then the sun poked through between some branches and all of a sudden they were sunlit. The direct sunlight highlights each droplet making them stand out more than under the diffused lighting.

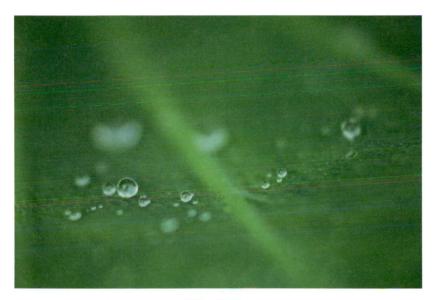

Diffused lighting.

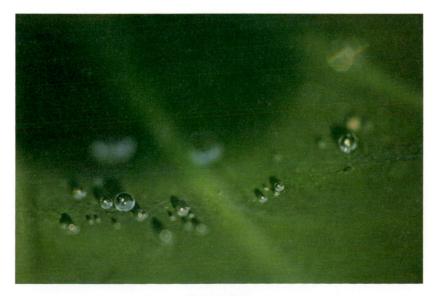

Direct sunlight.

Part 4

Lenses are one of the tools photographers use to share their view of the world. Just as changing your aperture affects the appearance of your subject, so can the choice to use a wide-angle lens vs. a telephoto lens.

The photos below, taken while standing in the same place, give you an idea of how much you can change just by zooming in or using different lenses. The focal length used is listed below each photo.

27 mm.

50 mm.

105 mm.

300 mm.

600 mm.

ZOOM LENSES

With a zoom lens you can change focal length by turning a ring on the lens, which is called a twist zoom. On some older lenses you would zoom by pushing and pulling the lens forward and back (a push/pull zoom). Zoom lenses give you a lot of flexibility because you can adjust your composition by turning the zoom ring. You may not have to move closer or further from your subject if you can get the shot you want by zooming in (a closer view) or zooming out (a wider view). The zoom lenses made today are very good quality and can produce excellent photos. They are a compact way to travel because you get many focal lengths in a single lens. Think of it this way: with a 17-55 mm lens you have a 17 mm lens, a 24 mm lens, a 35 mm lens, and a 50 mm lens all combined into one. There are a variety of zoom lenses available. Autofocus zoom lenses have two rings on the outside that rotate. One is the zoom ring and the other is the focusing ring. The zoom ring is usually larger and often toward the back of the lens, with the focusing ring closer to the front. In some lenses the focusing ring is actually the front of the lens.

A zoom lens allowed me to easily frame a tight shot of this lily pad in the middle of a pond.

FIXED FOCAL LENGTH LENSES

Fixed focal length lenses don't zoom, they remain at a single focal length. With these lenses you have to "zoom with your feet," meaning

you have to walk closer to or further from your subject to change how much you see. Fixed focal length lenses are also called prime lenses. They are often smaller and lighter weight than zoom lenses because their construction doesn't require as many pieces of glass (called elements). Prime lenses just have a focusing ring.

MAXIMUM APERTURE

Every lens has a maximum aperture, which is the largest possible opening for the lens. It's often f/2.8, f/3.5, or f/4. The maximum aperture is listed

24 mm fixed lens.

on the lens among the string of letters and numbers that make up the name of the lens. The 12–24 mm lens is listed as "AF-S DX Zoom Nikkor 12–24 mm f/4G IF-ED." Near the end of that lengthy name you see f/4, telling you the maximum aperture is f/4. Some zoom lenses will have a hyphenated aperture such as f/3.5–5.6. This is called a variable aperture. It means that at the wide end of the zoom range the maximum aperture will be f/3.5, but when you zoom to the longest focal length the max aperture will be f/5.6. Nikon's 18–135 mm lens has a variable aperture of f/3.5–5.6. At 18 mm the maximum aperture is f/3.5, but when you zoom to 135 mm it becomes f/5.6. In between 18 and 135 mm the maximum aperture gradually shifts from f/3.5 to f/5.6. You don't need to use a lens any differently because it's a variable aperture lens. Lenses that are variable aperture are smaller and lighter weight than a comparable lens with a fixed maximum aperture.

FOCUSING

Regardless of whether the lens is a zoom or fixed focal length, almost all current lenses will have the ability for you to either autofocus or manually focus. Whether you focus on your subject using autofocus or manual focus is largely personal preference. Autofocus is a quick way to bring your subject into focus because the camera does the work for you. If autofocus can't lock onto your subject then try manual focus. When doing close-up or macro photography manual focus is usually a better choice. With close-up photography you often want to be very precise with where you focus on your subject. For instance if you are photographing a small flower do you want to focus on the center of the flower or the edge of the petals? The camera won't know so you're better off manually focusing to place the focus in just the right spot. In comparison if you're photographing a landscape autofocus will do much better bringing your scene into focus.

By using manual focus I was able to precisely focus on the center of the flower.

Most Nikon autofocus lenses have a switch on the side of the lens to select autofocus or manual focus. The switch will be labeled in one of two ways: (1) A and M or (2) M/A and M. "A" mode is autofocus and "M" is manual focus. "M/A" means if you are in autofocus you can turn the focusing ring on the lens and it will automatically switch to manual focus. In M/A mode be aware that if you turn the ring to manually focus, then press the shutter release button halfway down the lens will activate the autofocus. With some lenses even if you're

in A mode you can still turn the focusing ring and manually focus and it will behave like an M/A switch.

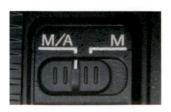

M/A and M focus switch.

WIDE-ANGLE LENSES

Wide-angle lenses range from 12 to 35 mm. Zooms will include some portion of this range.

12-24 mm.

Wide-angle lenses can be used to photograph a landscape where you want to capture the whole scene. They emphasize depth in a scene by showing the distance between different elements such as those in the foreground and background.

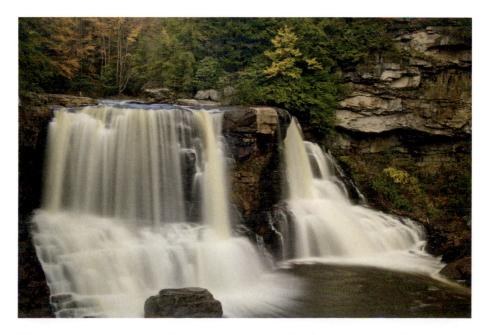

They can also be used to show a small piece of a landscape and emphasize a part of the scene that is very close to you.

Wide-angle lenses will make what is closest to the lens appear larger than what is further away. In this photo all the rocking chairs are the same size, but the one in front seems larger than the ones in the back.

STANDARD LENSES

A 50 mm lens is considered a standard focal length lens. Fixed focal length 50 mm lenses are available and they're excellent quality. There are also many zoom lenses that include the 50 mm focal length.

TELEPHOTO LENSES

The telephoto range goes from around 70 to 200 mm. Telephoto lenses allow you to photograph a small piece of a landscape, a portrait, or capture a close picture of something that is far away. They also visually compress the elements in your photograph, which makes everything seem closer together than it really is. There are many zoom lenses that include some or all of this telephoto range.

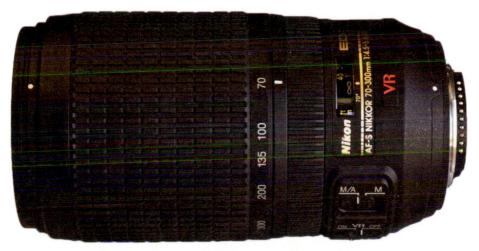

The 70-300 mm covers the whole range of the standard telephoto and then some.

Using a telephoto lens to photograph this river makes it look like the cascade is right in front of the trees.

SUPER TELEPHOTO LENSES

Super telephotos range from 300 to 600 mm. Lenses in these focal lengths are usually fixed focal lengths. Common focal lengths are 300, 400, 500, and 600 mm. There are some zooms that reach into this range, but not many. You can use these lenses in the same manner as shorter telephotos—isolating parts of a landscape and capturing close shots of far away subjects. Super telephotos will compress the elements and depth in a photograph even more than regular telephotos.

Small landscape details can be easily isolated with a telephoto lens.

I used a 300 mm lens to isolate the boat and create the feeling that there's nothing else around it in the water.

Super telephotos are more often used for photographing wildlife and sports, specifically the 500 and 600 mm lenses. With animals and athletes you often can't get close. So if you don't want a photo where the person or animal is very small you need a long lens to get a tight shot. If you look for the press photographers at a major sporting event you'll see they all have long lenses on monopods ready to capture the action.

Using a 300 mm lens allowed me to capture a good photo of these alligators while staying a safe distance away.

ZOOM LENS CHOICES

Zoom lenses come in so many varieties they don't fit neatly into the wide-angle, standard, telephoto, and super telephoto groups. Often a zoom lens will include focal lengths from more than one group. This is a good thing because you don't have to carry around lots of different lenses. You can probably do just fine with a couple lenses depending on what you like to photograph. A number of Nikon zooms go from wide-angle to the short or mid-telephoto range. A few examples are: 16–85 mm, 18–55 mm, and 18–135.

18-135 mm.

There are also high-power zoom lenses that start between 50 and 80 mm, then go up to 200 to 400 mm. Nikon's lenses in this range include the 55–200 mm, 70–300 mm, 70–200 mm, and 80–400 mm.

55-200 mm.

A great quality all around lens is Nikon's 18–200 mm. With this lens you're covered all the way from wide angle through telephoto. It even has the vibration reduction (VR) technology, a great benefit when photographing handheld. More info on VR coming up.

HANDHOLDING THE CAMERA

If you use too slow a shutter speed when handholding the camera your pictures will not be sharp. How do you know what a good shutter speed is? A good rule of thumb is to take the inverse of your lens' longest focal length. For example, if you have an 18–135 mm lens you would take 135 and make it 1/135. Then pick the closest shutter speed to 1/135, which is 1/125. The slowest shutter speed

you should use with your 18–135 mm lens is 1/125 of a second. Now this calculation is not a definitive answer, but it gives you an idea of where to start. Do some tests of your own, taking pictures at progressively slower shutter speeds and see when they become blurry. The longer the focal length of the lens, the faster your minimum shutter speed needs to be.

The bright sunlight coming from above the clouds made it easy to get a shutter speed fast enough for handholding.

VIBRATION REDUCTION

Some of Nikon's lenses have a feature called vibration reduction (VR). Vibration reduction is an image stabilization technology that helps to correct for your movement (such as hand shake) when you're taking a picture. There is one element (piece of glass) in the lens which moves, working to compensate for your movement. The benefit of VR is you can take handheld pictures at shutter speeds that are two to three stops slower than what you would use with a non-VR lens. Let's say you have a regular 18–135 mm lens, which means the slowest shutter you'd want to use is 1/125 of a second. If that were a VR lens you could reduce that minimum shutter speed to 1/30 or 1/15 of a second. 1/125

vs. 1/15? That's a big difference which gives you a lot more flexibility with when you can photograph.

If a lens has VR there will be a sliding switch on the side of the lens to turn VR on and off. Turn VR off if the camera is locked in place on a tripod. If you are using a monopod or the tripod head is loosed when shooting keep VR on. Some VR lenses have a "NORMAL/ACTIVE" switch below the On/Off which is related to VR. In most shooting situations (when using VR) you will set the switch to Normal. You should use the active setting if you're taking photos from a moving vehicle.

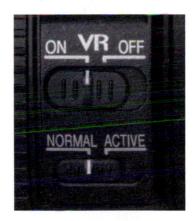

VR switches on a lens.

Vibration reduction can help you get a sharp picture while handholding the camera in dim lighting.

LENS HOODS

Lens hoods are an accessory that come with most lenses. They attach to the front of the lens and extend out. The shape of the lens hood is related to the lens it's made for. Here are a few examples:

A wide-angle lens will have a short lens hood; a telephoto lens will have a longer one. A wide-angle lens can't have a long lens hood because the edge of the lens hood would actually be in the picture. You'd see the edge of the hood when you look through the lens. This is because the lens has a wide angle of view and you see a lot of what is out to the sides of the lens. A telephoto lens has a narrower angle of view, it does not see as much "out to the sides," so the lens hood can extend further and not interfere with what you see.

The primary benefit of a lens hood is preventing lens flare. Flare is caused by the sunlight

coming directly into the lens and bouncing off the elements inside the lens. Lens flare is most likely to occur when it's sunny and the sun is in front of you or just off to either side. Wide-angle lenses are more susceptible to flare than telephoto lenses because they can't use as large of a lens hood. Flare can be very obvious in the form of one or more circular or polygonal shapes appearing in your photo. It can also be more subtle as a slight haze across all or part of your image. Keeping the lens hood on can help minimize flare. A lens hood won't always stop flare, particularly if you are photographing straight toward the sun. When the

lens hood isn't solving the problem, try holding your hand or hat to block the flare. What you're trying to do is shade the front of your lens without getting your hat or hand in the picture.

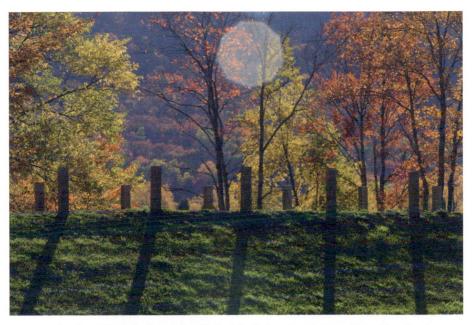

Lens flare: in addition to the flare circle notice how the flare creates a haze, washing out the rich color.

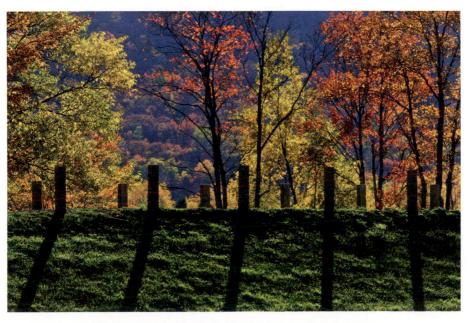

Flare eliminated by using a lens hood and shading the lens with my hand.

While photographing in a snow storm using a lens hood kept the snow off the front of my lens.

MACRO LENSES

If you like to take close-up pictures or photograph subjects that are very small, you may want to consider

a macro lens. Nikon makes three lenses for close-up photography, which they call "Micro" lenses: 60, 105, and 200 mm. These are all fixed focal length lenses. Macro lenses are specifically designed for close focusing. Every lens has a minimum focusing distance. To see how close one of your lenses can focus, switch to manual focus mode then slowly turn the focus ring to the left (counter clockwise) as far as it will go. I suggest turning it slowly because then you will be able to feel when the ring stops. The ring can continue to turn after its stopping point but it's no longer affecting the focusing. It's not doing any harm to the lens, but it's not doing you any good either. Once

you have the ring turned all the way to the left, look through the viewfinder and start moving closer to an object. As soon as the object is in focus stop. That's the lens' minimum focusing distance. If you get any closer you won't be able to bring the object into focus. If you had a macro lens to do the same test with (on the same object) you'd find that you

105 mm macro lens.

could get a lot closer and still keep the object in focus. This capability allows you to photograph small subjects or little details of larger subjects.

When you can get very close to a subject you can find interesting abstract patterns.

A macro lens allows you to capture small details like the center of this Echinacea.

Each of Nikon's macro lenses will produce excellent quality images. The benefit of using a longer focal length lens is you gain more working distance. You don't have to be as close to your subject to get the same photo. Let's say you were using the 60 mm macro lens and you had to be one foot away from your subject to get the picture you want. If you used the 105 mm lens you could be close to two feet away from the subject and get the same shot. Using the 200 mm lens you could be almost three feet away and capture the same image. A longer focal length would allow you to take a close-up picture of something even if you couldn't get really close to it. Also, if you were photographing a small animal such as a butterfly you may not want to get too close because it might fly away.

Composition & the Subjects

COMPOSITION TECHNIQUES

SUBJECT PLACEMENT AND THE RULE OF THIRDS

Often we place our subjects in the center of our photographs. It's an easy place to put the subject and easy to get the subject in focus. However, in terms of creating a compelling and interesting composition, the center of the photo is not a great place for the subject.

To start thinking about other places to put the subject there's a concept that goes by a couple names: the Rule of Thirds or Power Points. The idea is to divide your photograph into thirds both horizontally and vertically. It's like laying a tic-tactoe board over your image.

This creates four intersecting points: top left, top right, bottom left, and bottom right. Each of these points is a "power point," meaning they're good places to consider for placing your subject. Use these points as a compositional aid. The idea is to give you a rough idea of where to consider placing your subject. When you've chosen a subject and are selecting a composition keep the power points in mind. Move the camera around to place your subject near those four areas and see what looks good to you. In most cases one of those areas will be a better place for your subject than the center of the photo.

The center of interest in these compositions was placed near one of the power points.

Does this mean you should never place your subject in the exact center of your image? No. But if you do, you should have a specific reason for doing so. Consider this image where the power lines are in the center. The purpose of placing it in the center was to emphasize the symmetry and graphic design.

COMPOSITIONAL TIPS

• Another element to avoid placing in the middle is the horizon line. When you're photographing landscapes try placing the horizon above or below the center of the image.

The foreground of the composition is emphasized by placing the horizon near the top.

Lines can create a sense of movement and direct the eye. Often lines will lead the viewer's eye through an image, so it's important to be aware of lines when you compose a picture.

The curving lines of the road lead your eye back to the building.

- Looking at the world around you many things are made up of shapes.
 You can create eye-catching images by making shapes a primary part of the composition.
- Use color to your advantage. Put together complementary colors for pleasing color combinations or use a single bold color that dominates.
- Foreground objects add depth and scale to landscape photos.

The vibrant color of the azalea immediately grabs the viewer's attention.

WHILE YOU'RE OUT PHOTOGRAPHING...

- Walk around your subject to explore different angles/perspectives.
- Think about what is the best light for the subject (diffused, front lighting, side lighting, back lighting).
- Try photographing the same scene/ subject with different lenses (or different focal lengths on a zoom lens).
- Take both vertical and horizontal photos.
- Adjust your perspective: take pictures from up high and down low.
- Take multiple photos of a single subject/scene (there isn't just one right shot).

- Have a clear center of interest, so the viewer is not wondering what the subject of the picture is.
- Avoid distracting backgrounds.
- Include little or no sky in your composition if it's an overcast day (it will just appear as a white mass with no detail).

PORTRAITS & PEOPLE

- To achieve a soft, out-of-focus background when photographing one person use a wide aperture (f/4, f/5.6).
- Be ready to take the shot when the right expression happens.

 Be aware of what's happening behind your subject. You don't want a background that's taking attention away from the person. If you see

distracting background elements move to a different position to try and eliminate or minimize them.

- Try environmental portraits, where you show the area around the person.
- Take close portraits where the person's face or head and upper body are filling the viewfinder.
- The more photos you can take of someone, the better chance you have at capturing quality images. It's hard to take just one or two photos and have those turn out to be the best pictures. If you spend some time photographing a person it's often the photos near the end of the shoot that are the best. By that time both you and the subject have relaxed and the good pictures come easier.

LIGHT

- Soft, even lighting gives a pleasant look for portraits (overcast days or if people are in the shade).
- Avoid "top lighting," when the sun is overhead shining down on your subject. The result is not flattering: around the eyes is very dark along with heavy shadows under the nose and chin. This is made even worse if the person is wearing a hat, because the hat will also cast a shadow on the person's face.
- If you must photograph people when the lighting is casting harsh shadows use the D90's flash to help fill in the shadows. You may want to reduce the power of the flash (fill flash) so that the light from the flash isn't stronger than the sunlight.
- Avoid having people looking into the sun when you're taking their picture because they'll be squinting.

POSING

 Try posing your subject. At first it can be intimidating to tell someone where sit or stand, where to look, where to place their hands, etc. The more pictures you take where you pose the subject, the more comfortable you'll become with it. You'll also develop a better sense of what poses work best for which people. At first just try a few poses and vary the types of pictures you take of your subject. Have him/her sit for some pictures and stand for others. Take some pictures with your subject looking at the camera as well as looking slightly to the left and right. As you're taking pictures try different framing: head shots,

head and shoulder, waist up, full body. Also remember to take both vertical and horizontal photos.

- Look for an angle or perspective that is flattering to the person.
- For posed portraits people often lift their chin up, ask your subjects to lower their chin a little to improve their appearance.

PHOTOGRAPHING STRANGERS

- Be respectful and courteous.
- Ask permission to photograph if you'll be taking the photo from a close distance. If someone says no, respect their answer and don't take a picture.
- Tell people why you want to photograph them. Many people are flattered to have their photo taken. Compliment them so they feel good about your interest in photographing them.
- Talk to them first to "warm them up."
- People find long/large lenses intimidating. Don't use a long lens if you are going to be close to the people you're photographing.
- Be friendly, smile a lot, and thank the person afterwards.
- If you're far away with a telephoto lens it may not be necessary to ask permission if the person isn't aware you are taking their photo.
- Go to places/events where people are more likely to be open to being photographed such as parks, festivals and parades.

PHOTOGRAPHING CHILDREN

- Always be ready to capture the fleeting moments. The best photo could be a brief expression or action.
- Move down to their level.
- Spend time with them so they are more comfortable with you photographing them.
- A great time to photograph kids is when they are doing something else: playing, eating, playing a game, drawing, doing a project. Then they're paying attention to the activity and not you and your camera.
- If possible use natural light and avoid the use of flash. Your photos will have a more natural look and the use of flash may distract your subject.
- Certainly ask permission before photographing a stranger's child.
- If you're arranging a photo session, solid colors for clothes work well, soft colors too. If the colors are too bold and vivid they can take away from the child.
- Try giving a prop to a child; just something for them to play with while you photograph. This will help take the attention away from the fact they're being photographed. A prop can be something you bring with you or a toy they have.

TRAVEL

- Do some research ahead of time to know a bit about the area. culture. and people. This will put you in a better position to seek out interesting photos. You'll also know if there are any major events, such as festivals, taking place while you're there.
- Once you arrive go to a gift shop or other tourist outlet and check out the postcards. From the postcards you can find out what the local sights are and maybe even get some ideas about how to photograph them.
- · Consider how much camera equipment you want to carry. If you'll be walking around all day you may not want to be weighted down with lots of gear. Your D90 plus a wide-angle and telephoto lens will suffice for most photo opportunities.
- Strive for variety in your photos: use wide and telephoto lenses, take verticals and horizontals, shoot the wide scene and the details.

Look for interesting details when you're traveling.

- · Photograph the landscape, especially any notable landforms, as well as local plants and animals.
- You may travel somewhere that has a well-photographed famous landmark. Don't let that dissuade you from photographing it yourself. It's

your trip and it's worth capturing images of where you go and what you see. Try photographing the landmark in a way that it isn't normally seen. Look for an unusual perspective or photograph interesting details of the landmark in addition to the whole thing.

- · Look for details that reflect the towns and cities you visit, such as architectural features, signs, and food or crafts at a market.
- Capture the wide shot to show an overall view of the area.
- Photograph the locals—look for interesting expressions and clothing representative of the location.
- Visit a variety of areas: monuments, shopping areas/markets, landmarks.
- Get up high for a different perspective (skyscraper, church, bridge).
- · In a city try photographing the buildings and streets around sunset and after when the sky is dark blue, but not yet black. At this time of day you'll still have color in the sky but you'll also be able to record building and streetlights. Metering for this type of exposure can be tricky. Check your monitor and histogram after an exposure to see if vou need to make adjustments before the next photo. This type of shooting situation may require slow shutter speeds and a tripod to keep the camera still.

Experiment with different perspectives to give a fresh look to your photos.

PETS AND ANIMALS

Similar principles apply to photographing pets or other animals. You can usually just get a lot closer to your pet than a wild animal! Because of this when photographing your pet you really don't need a long telephoto lens.

- · Get down to their level. This perspective looks more natural than standing above looking down.
- Look for good lighting conditions.
- Focus on the eyes.
- Be ready! You can't expect pets or wild animals to take direction like
- Look for humorous behavior or an interesting pose.

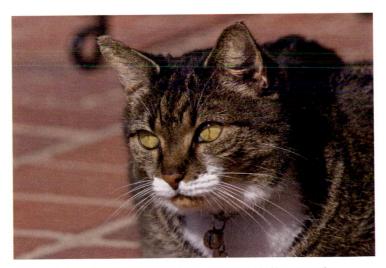

Photograph your pets down on their level for natural looking perspective.

- Telephoto lenses work best for wildlife so that you can take the picture from further away.
- · Small animals such as birds will be difficult to photograph without a long telephoto lens. You can get a sharp shot of them, but they end up being too small in the viewfinder.
- Short or moderate telephoto lenses can do a great job with larger animals such as deer, horses, dogs, etc.
- For animals in the wild your photos don't have to be tight portraits. Try taking environmental portraits where you show the animal in its habitat.
- Zoos aren't a bad place for animal photos either. They're convenient and have lots of animals to choose from. Try for a portrait shot to minimize the area around the animal. Use a large aperture and focus on the animal's eyes. You can sometimes even photograph through the bars on a cage, and by using a large aperture the bars won't be noticeable.

- Whether it's your pet or a wild animal anticipating their action and reacting quickly is key. Just like photographing people it can be the fleeting moments that make the best pictures.
- To practice wildlife photography visit a local park and photograph the wildlife there. Squirrels may not be an exotic subject but they can test your reflexes and give you some good practice.

Wildlife might not stay still very long, get your shot when you have the chance!

ACTION

- Recommended settings: set focus mode to continuous (AF-C), AF-area mode to dynamic area, and release mode to continuous so you can fire off a burst of photos at a time.
- To get a fast enough shutter speed you may need to raise you ISO to 400, 800 or higher depending on the lighting conditions.
- Use a telephoto lens. One in the range of 70–200mm is a good starting point.
- Longer lenses are good too but they are larger and more expensive.
- Use fast shutter speeds to freeze the action (1/250, 1/500, or faster depending on the speed of your subject).
- Try slow shutter speeds to create a motion blur (start with shutter speeds between 1/30 and 1/8 of a second).
- The closer you can get to the action the better because your subject will be larger in the frame.
- Look for the best place to photograph from, ideally a location where you have a clear view of the action. If you can visit where you will be photographing ahead of time you can scout out potential shooting locations.

- As the action is unfolding follow your subject in the viewfinder, then you're ready to take a picture when something interesting happens.
- Try to anticipate the action or the peak moment when you should take the picture. If you see the peak of the action beginning to come together, start shooting before the peak actually occurs. If you wait for the peak to start shooting you may miss the moment.
- When photographing sports such as baseball, football, tennis, basketball, or soccer try to include the ball in the photo.
- It helps if you're familiar with the action you're photographing. For instance, if you know how the game is played or where the race is going you'll have a better chance at anticipating and capturing the action.
- Last but not least a background that isn't distracting will help keep the attention on your subject. However, there's a lot to think about already so first focus on getting a sharp picture and capturing those peak moments.

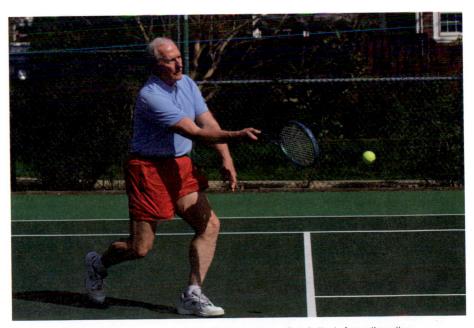

Anticipate when the peak of action will occur and use a fast shutter to freeze the action.

PRODUCTS

One of the most important things for product photography is to make the product look good.

- Make sure the product is in good condition.
- Find a background that is not distracting. A solid colored background works very well.
- A basic black or white background is a good choice. Color of your product will dictate whether a dark or light background is better.
- Light the product with evening lighting. Harsh lighting is an unattractive way to present a product.
- You can purchase a light tent which is a box made out of translucent fabric. One side is open and you place a background material inside, then place your product in the box. Set up lights to shine through the fabric sides. This produces a soft, even light over your subject.
- You can create a simple setup that that doesn't take up much space. It doesn't have to be expensive and can produce high quality results.

The black backdrop nicely sets off the light colored bottles.

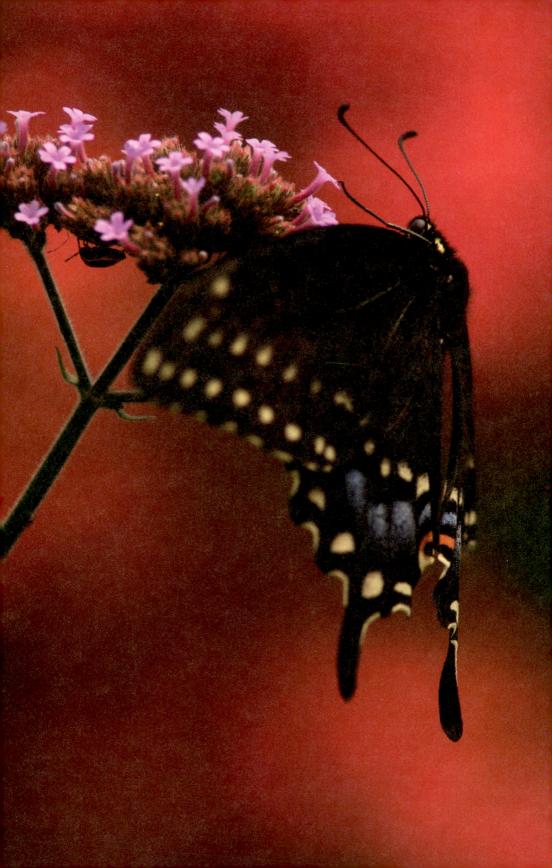

Accessories

FLASH UNITS

Nikon makes external flash units that fit into the accessory shoe ("hot shoe") on top of the D90. Three flash units to consider are the SB-400, SB-600 and the SB-900. The SB-400 is the most compact of the three. The head of the SB-400 can be rotated upward 90 degrees to point toward the ceiling. This enables the use of bounce-flash. If you want more power and flexibility look at the SB-600 and SB-800. You can control both of these speedlights wirelessly with your D90. That makes for a versatile and powerful system. The SB-600 can sit on the camera or it can be off the camera and controlled by the builtin flash. The SB-900 can do the same things as the SB-600 and more. An SB-900 can be a master flash unit, meaning it can control other Nikon flashes, it can put out a more powerful flash burst and is more customizable.

The D90 comes with a cover over the accessory shoe. This needs to be removed to attach an external flash unit. Slide the cover toward the back of the camera to remove it. It's fitted in the accessory shoe quite tightly so it doesn't slide out very easily. If you're not using an external flash you can leave the cover in place.

REMOTE CONTROL

The ML-L3 remote (not included with the D90) is used to take pictures in the Delayed Response and Quick Response shooting modes. Nikon's specifications state that you shouldn't

be more than 16 feet away from the camera when using the remote. However, I had no problem using the remote 24 feet away from the camera. Even though it's also recommended you point the remote at the infrared receiver on the front of the camera, the remote will work when held behind the camera. Just have the front of the remote pointing at the back of the camera. If this doesn't happen to work you can always reach your hand around so the remote is pointing toward the front of the camera.

Nikon also makes a wired remote, the Remote Cord DC-2, which attaches using the accessory connector on the left side of the camera. The remote's cord is three feet long so you don't have to be right next to the camera to use it. With the DC-2 you can activate the Bulb settings (in manual exposure mode) and not have to worry about camera shake.

FILTERS

There are two filters I recommend you consider: UV/skylight and a polarizer.

UV/SKYLIGHT

The UV/Skylight filter is a clear filter whose main purpose is protecting the front of your lens. You might see some packaging or promotional information that says how these filters will improve the colors in your photos. If they do I don't think it's in any appreciable amount. If you buy one for your lens do it for protection, not to improve your photos. There is no requirement to use one, just personal preference.

If you're photographing at the beach where salt spray is likely to get on the front of your lens you should use a UV filter even if you don't normally use one. The salt spray can damage the coating on your lens.

POLARIZER

I think the polarizer is the most important all around filter if you're taking outdoor/nature photographs. You'll want to get a circular polarizer, not a linear one. A polarizer is made up of two pieces of glass and you rotate the front of the polarizer to adjust the amount of polarization. Polarizers can significantly improve your photos in certain situations.

Polarizers can reduce or remove the glare and reflection from many surfaces. Outside you'll find it takes glare off water (lakes, rivers), wet surfaces, and waxy foliage. It'll even do the same for a car hood or a shiny table. When it removes the glare it appears to increase saturation because the colors look richer. It's not actually adding saturation. When you see leaves, for instance, with a glossy surface their color is a little washed out. By removing the glare the true color is revealed.

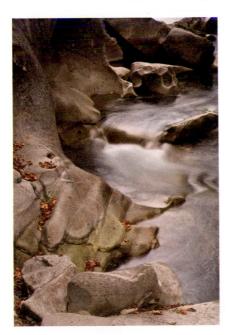

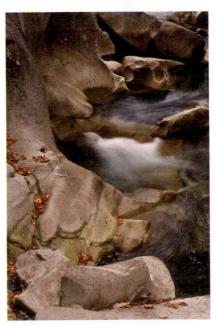

Polarizer removes the glare from the water.

Polarizers can also darken blue skies depending on the angle to the sun. A polarizer will have the greatest effect on the sky when pointed at 90 degrees to the sun. It will have no effect when pointed directly at the sun or directly opposite the sun. As you turn the polarizer you'll see the blue in the sky darken. The darkening of the blue will also make clouds stand out better. At high elevations and in the southwestern area of the United States it's possible to over polarize and make the sky unnaturally dark, almost black. In these situations you can still use a polarizer, just don't turn it to the maximum amount of darkening.

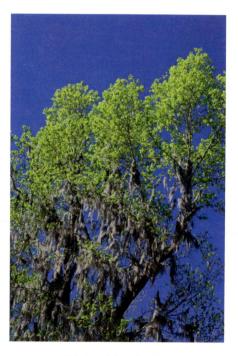

Polarizer darkens the sky.

VIEWFINDER ACCESSORIES

Diopter Adjustment Viewfinder Lenses: At the beginning of the book I described how to set the diopter so that the markings in the viewfinder appeared sharp. If you were unable to correctly set the diopter for your eyesight there are additional diopter lenses you can purchase so that you correctly set the diopter for your eyes.

Eyepiece Magnifier DG-2: This accessory magnifies what is seen at the center of the viewfinder. It requires the DK-22 adapter to connect it to the D90.

Right Angle Viewing Attachment DR-6: The right angle viewing attachment attaches to the viewfinder eyepiece and sticks straight up. It allows you to see through the viewfinder from just above the top of the camera. This accessory is most useful when you're photographing close to the ground. If the D90 is on a tripod right near the ground you may have to lie down on the ground to see through the viewfinder. The right angle attachment would allow you to look down into the viewfinder from a kneeling position.

HDMI CABLE

Use a type C mini-pin HDMI cable to connect the D90 to a high definition device.

POWER SOURCES

AC ADAPTER

You can purchase an AC adapter for the D90 that enables you to power it by plugging it into an outlet. The main use for this would be if you're photographing in a studio or other indoor location where you won't need to move around much. The D90 uses the EH-5a/EH-5 AC Adapter.

MULTI-POWER BATTERY PACK MB-D80

The MB-D80 can hold two batteries, allowing you to go longer before running out of power or having to change batteries. It fits onto the bottom of the D90. The MB-D80 has a shaft that slides into the battery compartment of the D90, then the rest of it connects to the bottom of the D90 using the tripod socket. It has other useful features as well. The shape of the battery pack also makes it a vertical grip, which is convenient to use when taking vertical photos. Also, positioned conveniently on the battery pack are main and sub-command dials, a shutter release button, an AE-L/AF-L button and a multi selector. So when you're holding the camera in a vertical orientation you have the same easy access to all the buttons and dials.

Corey Hilz

www.coreyhilz.com

Author's Web site including an online glossary companion to the book.

Blog: http://web.me.com/coreyhilz

Nikon

http://nikonusa.com/

Nikon's Web site for the United States.

Nikonians

http://www.nikonians.org/

Online community of Nikon photographers. Gear information, reviews, forums, and more.

Photo.net

http://photo.net/

Online photo community.

Flickr

http://www.flickr.com/

See the photos of others and share your work. Online photo albums and organization tools available.

Rob Galbraith Digital Photography Insights

http://robgalbraith.com/

Photo industry news.

Digital Photography Review

http://dpreview.com/

Detailed product reviews, product announcements, and photo industry news.

Outdoor Photographer Magazine

http://www.outdoorphotographer.com/

Photo tips, information about gear, and where to go to photograph.

244 Links

Popular Photography

http://www.popphoto.com/

Product information, reviews, how-to information, and more.

Nature's Best Photography

http://www.naturesbestmagazine.com/

Photography contests and publishers of a magazine with stunning images of the natural world.

Nik Software

http://www.niksoftware.com/

Software plug-ins for Photoshop, Photoshop Elements and Aperture. Includes software for sharp-ening, noise reduction, selective color adjustments, black and white conversion and filter sets.

Visible Dust

http://visibledust.com/

Products for cleaning your sensor.

Lensbabies

http://lensbabies.com/

Selective focus lenses for SLR cameras.

Auto ISO, 34-5 3D-Tracking mode, 47 Auto meter-off delay, 111 Auto modes: Digital Vari-Programs, 22-5 AC adapter, 241 standard auto mode, 22 Auto Red-Eve, 181 Accessories: filters, 238-40 Auto retouch brush, 185 Auto-Servo Autofocus mode, 42 flash units, 237 HDMI, 241 Auto slow-sync, 56 power sources, 241 with red-eve reduction, 56 remote control, 237-8 Auto white balance, 49, 50, 97 viewfinder accessories, 240 Autofocus, 44, 207, 208 AE-L/AF-L for MB-D80, 108 Action mode, 24 AF-area mode, 105 Action shots, 232-3 AF point illumination, 106-7 Active D-Liahtina, 68, 101 Active Folder, 103 built-in AF-assist illuminator, 106 center focus point, 105-6 "Add Items", 146 challenges, 47-8 ADL bracketing, 120, 121 focus point wrap-around, 107 Adobe RGB color space, 101 AE & Flash setting, 120, 121 live view, 60-1, 108-9 AE lock, see Timers/AE lock Autofocus area modes, 45 3D-Tracking, 47 AE Only setting, 120, 121 AE-L/AF-L button, 48-9, 108 auto-area, 46 AF-area mode, 105 dvnamic area, 46 single point, 45 AF point illumination, 106-7 Autofocus modes, 42 Animals and pets, photographing, 231-2 Auto-Servo Autofocus, 42 Aperture, 6-8 Continuous-Servo Autofocus, 43 Aperture Priority, 16, 18-19 Assign AE-L/AF-L button, 123-4 Single-Servo Autofocus, 42-3 Assign function button, 122-3 Autofocus zoom lenses, 206 "Attach comment", 131 Auto-area mode, 46 Auto bracket set, 120-1 Auto Color Aberration, 181 Back lighting, 194 Backup copy, of photos, 154 Auto flash, 55 with red-eye reduction, 56 Backup Destination tab, 159-60 Basic info screen, 64-5 Auto FP, 121

Auto image rotation, 131

Batteries, 148

Color space options, 101

D. II	
Battery info screen, 132	Color temperature, choose, 51
Beep feature, 40, 113	Commander mode, 119, 120
Bird photography, 231	Composition techniques, 223
Bird's Eye palette, 181	action, 232–3
Black, white and neutral control points, 182-3	compositional tips, 225-6
Blower, 149	light, 227
Blue intensifier, 138, 139	photographing children, 229
Bracketing/flash, 27-8	photographing pets and animals, 231-2
auto bracket set, 120-1	photographing strangers, 228
auto FP, 121	portraits and people, 227
bracketing order, 121	posing, 228
flash control for built-in flash, 119-20	products, 234
flash shutter speed, 118	subject placement and Rule of Thirds, 223-4
modeling flash, 120	travel, 229-30
Brush, 148	Computers:
Built-in AF-assist illuminator, 106	backup copy, of photos, 154
Bulb setting, 11	folder, naming convention of, 154
	Continuous release mode, 38-40
	Continuous-Servo Autofocus, 43
	Contrast, 180
Camera:	Controls:
cleaning, 148-9	assign AE-L/AF-L button, 123-4
settings, 178, 179	assign function button, 122-3
shake, 41-2	customize command dials, 124-5
Camera & Lens Corrections, 179, 181	illumination switch, 122
Capture NX, see Nikon Capture NX	no memory card option, 125-6
Card reader, 148	OK button (shooting mode), 122
downloading using, 155	reverse indicators, 126
Center focus point, 105-6	Convert Files button, 170
Center-weighted area, 110	Crop Tool, 182
Center-weighted metering, 36	Cross screen filter, 139
Children, photographing, 229	Custom Setting Menu, 104
"Choose Tab", 145	autofocus, 105-9
CL mode shooting speed, 115	bracketing/flash, 118-21
"Clean at" option, 128	controls, 122-6
Clean image sensor, 127-8, 149	metering/exposure, 109-11
"Clean now" option, 128	reset custom settings, 105
Cleaning camera, 148-9	shooting/display, 113-18
Close-up mode, 17, 24	timers/AE lock, 111-13
Close-up photography, 218	Customize command dials, 124-5
Cloudy setting, 51	Customize Toolbar, 167
Color, 189, 190, 226, 234	Cyanotype images, 137, 138
Color Balance, 139-40	
Color Booster, 166	\Box
Color control Point, 183-4	\cup
Color Moire Reduction, 181	D-Lighting, 134-5, 166

DC-2, see Remote Cord DC-2

Delayed remote, 40	review, 25
Delete, 82-4	Shutter Priority, 17–18
see also Photos: deletion	Extension, in grouping, 161
Depth of field, 8-10	Eyepiece magnifier DG-2, 240
preview button, 29	
Detail:	Г
losing, 69-71	F
screens, 66–8	F/4 aperture, 6, 8
Develop section, 178–81	F/5.6 aperture, 6, 9
Diffused lighting, 195	F/8 aperture, 6, 7
vs. direct sunlight, 199	F/11 aperture, 6, 7, 9
Digital Vari-Program modes, 22, 55	F/16 aperture, 6, 7
Action mode, 24	F/22 aperture, 6, 7, 8, 9
Close-up mode, 24	F-stop, see Aperture
Flash Off mode, 23	F-stop numbers, 6, 8
Landscape mode, 23	Face priority, 60, 108
Night Portrait, 24	File number sequence, 115–16
Portrait mode, 23	Fill/remove tool, 185
Diopter adjustment viewfinder lenses, 240	Filter effects, 138-9
Direct Select Tool, 182	Filtering:
Direct sunlight, 50	by file type, 177
vs. diffused lighting, 199	by number labels, 176
Display mode, 86–7	by star ratings, 176-7
Distortion control, 143–4	Fine tune optimal exposure, 110-11
Downloading:	Firmware version, 133
quick download instructions, 156	Fisheye, 144-5
using camera, 155-6	Fixed focal length lenses, 206-7, 218
using card reader, 155	Flare, of lens, 216, 217
Dry cleaning, 150	Flash compensation, 57-9
Dynamic Area mode, 46, 47, 105	Flash control for built-in flash, 119–20
Dynamic / 10a mode, 40, 41, 100	Flash modes, 54-5
_	auto flash, 55
	auto slow-sync, 56
Easy exposure compensation, 109–10	default settings, 55
Edit List, 178, 181	flash off, 55
EH-5a/EH-5 AC Adapter, 241	flash on, 55
E-mail button, 168	flash pops up, 55
Embedded Info tab, 157–8	with P, S, A, and M exposure
Enable release, 125, 126	modes, 55
EV steps for exposure control, 109	rear curtain sync, 56-7
Exposure compensation, 25–7, 166, 180	red-eye reduction, 56
Exposure delay mode, 117	slow sync, 56
Exposure modes, 16–17	Flash off, 23, 55
Aperture Priority, 18–19	Flash on, 55
Auto modes, 22-5	Flash Only setting, 120, 121
Manual mode, 20-2	Flash setting, 50
Program, 17	Flash shutter speed, 118

Flash units, 237 Flash warning, 117-18 Fluorescent fine-tuning, 98 Fluorescent lighting, 50 FM Photography (Shutterhat), 196 Focus indicator, 44-5 Focus lock, 48 Focus Point, 167 Focus point wrap-around, 107 Focusing, 207-8 Folders, 161, 163, 164 Format memory card, 127 Front lighting, 192 vs. side lighting, 198 Full Page print, 168 Full screen, 175-5 and thumbnails, 175-6

GPS, 133
Gradient tool, 185
Green intensifier, 138, 139
Grouping options, 161–2

Hand Tool, 182
Handholding camera, 214, 215
HDMI, 79–80, 129, 241
Hide image, 85–6
High ISO Noise Reduction, 102
Highlight Protection, 180
Highlight screen, 65–6
Histogram button, 174
Hue adjustment, 94

l' button, 174 Illumination switch, 122 Image comment, 130–1 Image Dust Off Ref Photo, 132 Image overlay, 141 Image quality, 29–31, 95–6 Image review, 87 Image size, 31–2, 96 Image Viewer, 173–4 Images browsing, 63
basic info screen, 64–5
detail 1 screen, 66
detail 2 screen, 67
detail 3 screen, 68
highlight screen, 65–6
overview screen, 68–9
RGB histogram screen, 65
Incandescen lighting, 50, 52, 53, 54
Inclement weather, 196–7
Index print, 92, 168
IPTC information, 157, 158
ISO display and adjustment, 114
ISO Sensitivity Settings, 100
ISO setting, 32–4

JPEG, 29–30, 31, 95, 142

Kata (GDC Elements Cover), 196

Labeling images, 170–1
Landscape mode, Digital-Vari
Program, 23
Landscape setting, 94
Landscapes photographing, 225
Language, setting, 130
Lasso & Marquee Tools, 185
LCD brightness, 127
LCD illumination, 117
Lens flare, 216, 217
Lenses, 203

nses, 203
fixed focal length lenses, 206–7
focusing, 207–8
handholding camera, 214
lens hoods, 216–18
macro lenses, 218–19
maximum aperture, 207
standard lenses, 210
super telephoto lenses, 212–13
telephoto lenses, 211
vibration reduction, 215

wide-angle lenses, 209-10

zoom lens choices, 213-14	Mirror lock-up, see Lock mirror up for
zoom lenses, 206	cleaning
Levels & Curves, 180	Mixed lighting, 49
Light, 189, 227	Auto White Balance, 50
comparison, 197-9	cloudy setting, 51
direction, 192-5	color temperature, 51
inclement weather, 196-7	direct sunlight, 50
natural light, 189–91	flash, 50
Lines, 225	fluorescent lighting, 50
Live view, 59-61	incandescent/tungsten lighting, 50
autofocus, 108–9	preset white balance, 51-4
Lock mirror up for cleaning, 128	shade, 51
Long Exposure Noise Reduction, 102	ML-L3 remote, 40, 237
Loss of detail, 69–71	Modeling flash, 120
Loss of dotally do 17	Monitor off delay, 112
	Monochrome setting, 94, 137–8
M	Morning and afternoon lighting, 191
M/A mode, 208	Movie Settings, 103, 104
Macro lenses, 218–19	quality options, 62
	Multi-power battery pack MB-D80, 241
Maintenance:	
camera cleaning, 148–9	Multiple Exposure, 103
sensor cleaning, 149–50	Multiple photos, viewing, 74-6
Manage Picture Control, 95	My Menu, 146
Manual focus, 44, 207, 208	My Picturetown tab, 160
Manual mode, 16, 20-2, 119	
Matrix metering, 35	N
Max sensitivity, 34	IV
Maximum aperture, of lenses, 207	Natural light:
MB-D80 battery type, 118, 241	mid-day, 191
Memory cards, 29-30, 147-8	morning and afternoon, 191
Menus:	sinrise and sunset, 189-90
Custom Setting Menu, 104-26	time of day, 189
My Menu, 146	NEF (RAW) processing, 30, 142
navigation, 81	Neutral setting, 94
Playback Menu, 82-92	Night Portrait, 17, 24
Recent Settings, 145	Nikon Capture NX, 31, 132, 153, 178
Retouch Menu, 134-45	additional palettes, 181
Setup Menu, 126-33	Develop section, 178-81
Shooting Menu, 92-104	toolbar, 181-5
Metadata palette, 163, 164-5	Nikon Transfer, 153, 155
Metering, 35, 109-11	Backup Destination tab, 159-60
center-weighted metering, 36	my Picturetown tab, 160
matrix metering, 35	options section, 156-8
spot metering, 37	Preferences tab, 160
Micro lenses, 218	Primary Destination tab, 158-9
Microfiber cleaning cloth, 149	quick download instructions, 156
Mid-day lighting, 191	Thumbnails section, 161-2
Min shutter speed, 34, 35	Transfer Queue section, 162-3

Nikon ViewNX, 153, 163	bracketing, 27-8
filtering by file type, 177	bulb setting, 11
filtering by number labels, 176	camera shake, 41-2
filtering by star ratings, 176-7	depth of field, 8-10
folders palette, 163, 164	depth of field preview button, 29
Full Screen, 174-5	exposure, 3-5
Image Viewer, 173-4	exposure compensation, 25-7
labels, 170-1	exposure modes, 16-25
metadata palette, 163, 164-5	flash, 54-5
Quick Adjustment palette, 163, 165-6	flash compensation, 57-9
ratings, 171-2	flash modes, 55-6
sort order, changing, 177	focus indicator, 44-5
Thumbnail Grid, 172	focus lock, 48
thumbnails and full screen, 175-6	image quality, 29-31
toolbar, 166-70	image size setting, 31-2
viewing and sorting, 172	ISO, 32-4
No memory card option, 125-6	live view, 59-61
Noise, 33, 101	metering, 35-7
Noise reduction, 101-2, 179	mixed lighting, 49-54
Normal area, 61, 108	recording movies, 61-2
	release modes, 37-41
\cap	remote on duration, 41
\cup	shutter speed, 10-11
OK button (shooting mode), 122	white balance, 49
OP/TECH USA (Rainsleeve), 196	Playback folder, 84-5
Options section, 156	Playback menu:
Embedded Info tab, 157-8	delete, 82-4
Source tab, 156	display mode, 86-7
	hide image, 85-6
D	image review, 87
Γ	pictmotion, 88-9
Pets and animals, photographing,	playback folder, 84-5
231–2	print set (DPOF), 89-90
Photos:	rotate tall, 88
deletion, 72	slide show, 89-90
downloading, 148	"Point-and-shoot" mode, 22
protection from deletion, 72	Polarizer filter, 239-40
Pictmotion, 88-9	Portrait mode, 23
Picture Control, 166, 179	Portrait setting, 94
Pictures, making:	Portraits and people, 227
Active D-Lighting, 68, 101	Posing, 228
AE-L/AF-L button, 48-9	Power Points, 223
aperture, 6-8	Power sources, 241
Auto ISO, 34-5	AC adapter, 241
autofocus area modes, 45-7	MB-D80, 241
autofocus challenges, 47–8	Preferences tab, 160
autofocus modes, 42-3	Preset white balance, 51-4

Primary Destination tab, 158 D-Lighting, 134-5 photos renaming, during transfer, 159 distortion control, 143-4 subfolder creation, for each transfer, 159 filter effects, 138-9 Prime lenses, see Fixed focal length lenses fisheve, 144-5 Print As drop down menu, 168 image overlay, 141 Print button, 167 monochrome, 137-8 Print set (DPOF), 89-90 NEF (RAW) processing, 142 Product photography, 234 quick retouch, 142-3 Program mode (P), 16, 17 red-eve correction, 135 small picture tool, 140-1 straighten tool, 143 trim, 136 Quick adjust, 94 Reverse indicators, 126 Quick Adjustment palette, 163, 165-6 RGB histogram, 65 Quick Fix, 178, 179, 180 Right angle viewing attachment DR-6, 240 Quick-response remote, 40-1 Rocket blower, see Blower Quick retouch, 142-3 Rotate button, 167 Rotate Tall, 88 Rotate Tool, 182 Rule of Thirds, the, 223 Rating images, 171-2 Raw processing, see NEF (RAW) processing Rear curtain sync, 56-7 Recent Settings, 145 Saturation, 94, 180 Recording movies, 61-2 SB-400, 237 Red intensifier, 138, 139 SB-600, 237, Red-eye control point, 185 SB-800, 237 Red-eye correction, 135 SB-900, 237 Red-eve reduction, 56 Screen tips, 115 with auto flash, 56 SDHC cards, 147, 148 with auto slow-sync, 56 Secure Digital (SD) memory cards, 147, 148 with flash on, 56 Selection Brush, 185 with slow sync, 56 Selection control point, 185 Release locked, 125, 126 Selection Gradient, 185 Release modes, 37 Self-cleaning sensor, 149 continuous release mode, 38-40 Self-timer, 40, 41, 112 delayed remote, 40 Sepia tone images, 137 quick-response remote mode, 40-1 Set Picture Control, 93-5 self-timer, 40 Setup Menu, 126 single-frame release mode, 38 auto image rotation, 131-2 Remote control, 237-8 battery info, 132 Remote Cord DC-2, 238 clean image sensor, 127-8 Remote on duration, 41, 113 firmware version, 133 Repeating flash mode, 119 format memory card, 127 Reset custom settings, 105 GPS. 133 Retouch Menu: HDMI, 129

image comment, 130-1

color balance, 139-40

Setup Menu (Continued)	Side lighting, 193
Image Dust Off Ref Photo, 132	vs. front lighting, 198
language, 130	Single-frame release mode, 38
LCD brightness, 127	Single Point mode, 45, 47
lock mirror up for cleaning, 128	Single-Servo autofocus, 42–3
video mode, 129	
world time, 129–30	Skylight filter, 138
	Slide show, 76–7, 89–90, 169
Shade, in mixed lighting, 51	SlideShow button, 169
Shadow Protection, 180	Slow sync mode, 56
Shake, of camera, 41–2	with red-eye reduction, 56
Shapes, 226	Small picture tool, 140–1
Sharpening, 94	Software:
Shooting Date, in grouping, 161	Capture NX, 153, 178–85
Shooting/display:	image library, building, 153-5
beep, 113	Nikon Transfer, 153, 155-63
CL mode shooting speed, 115	Nikon ViewNX, 153, 163-78
exposure delay mode, 117	Sort order, changing, 177
file number sequence, 115–16	Source tab, 156
Flash Warning, 117-18	Sports, photographing, 233
ISO display and adjustment, 114	Spot metering, 37
LCD illumination, 117	SRGB color space, 101
MB-D80 battery type, 118	Standard Auto mode, 22
screen tips, 115	Standard lenses, 210
shooting info display, 116	Standard Photo Sizes, 168
viewfinder grid display, 113-14	Standard setting, 93, 94
viewfinder warning display, 114	Straighten tool, 143, 182
Shooting info display, 116	Strangers, photographing, 228
Shooting Menu, 92	Subject placement and Rule of Thirds, 223-4
Active D-Lighting, 101	Sunrise and sunset photographs,
Active Folder, 103	189–90
color space, 101	Super telephoto lenses, 212-13
High ISO Noise Reduction, 102	
Image Quality, 95-6	_
Image Size, 96	
ISO Sensitivity Settings, 100	Telephoto lenses, 211, 231
Long Exposure Noise Reduction, 102	Thumbnail Grid, 172
Manage Picture Control, 95	Thumbnails and full screen, 175-6
Movie Settings, 103-4	Thumbnails section, 161
Multiple Exposure, 103	Grouping options, 161-2
Noise reduction, 101-2	Time of day, for photographing, 189
Set Picture Control, 93-5	Timers/AE lock, 111-13
white balance, 97-9	auto meter-off delay, 111
Shutter priority (S), 16, 17–18, 25	monitor off delay, 112
Shutter-release button AE-L, 111	remote on duration, 113
Shutter speed, 10–11, 12–16, 17, 18,	self-timer, 112
20, 34	shutter-release button AE-L, 111
see also Min shutter speed	Toolbar, 166–70, 181–5

"Top lighting", 227
Transfer Queue section, 162–3
Transitions, 169
Travel, 229–30
Trim, 136
TTL, 119
TV, viewing photos on, 77–80
Twist zoom, 206

UN/Skylight filter, 238-9

V
Variable aperture lenses, 207
Vibration reduction (VR), 215
Vidco mode, 77, 78, 129
Viewfinder:
accessories, 240

grid display, 113–14 warning display, 114 Viewing and sorting, 172 Viewing/reviewing images: detail losing, 69–71 images browsing, 63–9 multiple photos, 74–6 on TV, 77–80 photos deletion, 72
photos protection, from deletion, 72
playback summary, 71
slide shows, 76–7
zooming in, 73–4
ViewNX, see Nikon ViewNX
Vignette Control, 181
Visible Dust, 150
Vivid setting, 93, 94

V V
Warm filter, 138
WB bracketing, 120, 121
Wet cleaning, 150
White balance, 49, 97–9, 166, 179
Wide-angle lenses, 209–10, 216
Wide area, 61, 108
Wildlife photography, 232
World time, 129–30

Zoom lenses, 206, 207, 211 choices, 213–14
Zoom Tool, 182
Zooming in, 73–4
Zoos, photographing in, 231

Focal Press

Monthly Photography Contest

The Focal Press Monthly Photography Contest is open to everyone. Each month has a different theme, ranging from black and white photography to wedding and nature photography. Monthly prizes and bi-annual grand prizes are awarded. There is an online voting system and guest judges from among Focal authors and the Focal editorial team.